A PORTRAIT OF
OUR NATION IN 2020

INTRODUCTION

When we look back at the COVID-19 pandemic in decades to come, we will think of the challenges we all faced – the loved ones we lost, the extended isolation from our families and friends, and the strain placed on our key workers. But we will also remember the positives: the incredible acts of kindness, the helpers and heroes who emerged from all walks of life, and how together we adapted to a new normal.

Through *Hold Still*, I wanted to use the power of photography to create a lasting record of what we were all experiencing – to capture individuals' stories and document significant moments for families and communities as we lived through the pandemic.

In May 2020 we asked the public to send in photographs which showed their experiences of life in lockdown and we were thrilled by the response. Over 31,000 submissions were received from people of all ages and backgrounds, and from all parts of the United Kingdom. One hundred final images were chosen, creating a collective portrait of our nation. From photographs of NHS staff caring for those battling the virus, to families sharing tender moments through closed windows, each of the images gave an insight into what others were going through during this unprecedented time.

For me, the power of the images is in the poignant and personal stories that sit behind them. I was delighted to have the opportunity to speak to some of the photographers and sitters, to hear their stories first-hand – from moments of joy, love and community spirit, to deep sadness, pain, isolation and loss.

A common theme of those conversations was how lockdown reminded us about the importance of human connection and the huge value we place on the relationships we have with the people around us. Although we were physically apart, these images remind us that, as families, communities and as a nation, we need each other more than we had ever realised.

Thank you to Nicholas Cullinan and our fellow judges for the time they invested in the project and their thoughtful consideration throughout the judging process. I would also like to extend my gratitude to everyone at the National Portrait Gallery for embracing *Hold Still* so enthusiastically, and for their dedication and support in helping to bring this project to life. My thanks also to the Co-op for all that they did in helping to take the final portraits back to the communities and people who created them, through our community exhibition and this book.

Finally, I would like to thank everyone who took the time to submit an image – your stories are the most crucial part of this project. I hope that the final 100 photographs showcase the experiences and emotions borne during this time in history, pay tribute to the awe-inspiring efforts of all who have worked to protect those around them, and provide a space for us to pause and reflect upon this unparalleled period.

HRH THE DUCHESS OF CAMBRIDGE

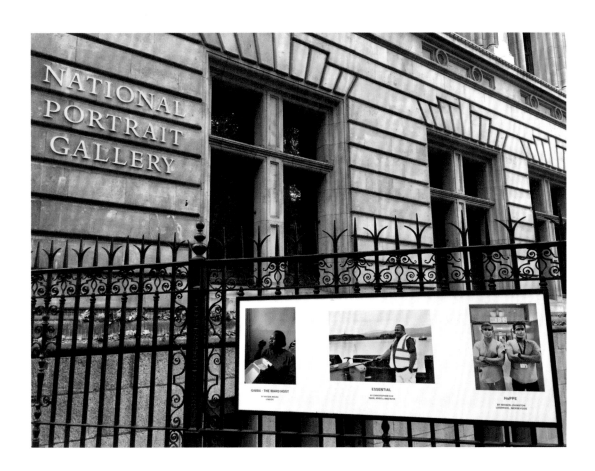

DIRECTOR'S FOREWORD

Since its founding in 1856, the National Portrait Gallery, has existed to record British history through portraiture. In 2020, it became even more important for the Gallery to find ways to document and share our individual and collective stories, as the coronavirus pandemic impacted everybody's lives in a multitude of ways.

Together with Her Royal Highness The Duchess of Cambridge, Patron of the National Portrait Gallery, in May 2020 we launched *Hold Still*, an ambitious project to create a portrait of the UK during lockdown. Each and every person across the nation was invited to share their portraits with us. The public response to *Hold Still* has been phenomenal, and we received an incredible number and range of images from all corners of the country.

Selecting the final 100 from over 31,000 images was not easy, and my sincere thanks go to The Duchess of Cambridge, who spearheaded this project and has devoted so much time and energy to it, and our fellow judges: Chief Nursing Officer for England, Ruth May; writer and poet, Lemn Sissay MBE; and photographer, Maryam Wahid, for taking on such a unique and challenging task with such dedication. During the course of the judging, we saw so many moving and inspiring images that will stay with us for many years to come.

In September 2020, we unveiled the *Hold Still* digital exhibition. Within the first three days, we received a record-breaking 250,000 visits to the site, and have had 5.6 million page views since the exhibition opening to the time of publication. Much has changed one year after the initial launch of *Hold Still*, including further periods of lockdown and sadly more deaths, including that of Captain Sir Tom Moore, who raised almost £33 million for the NHS and is represented in one of the selected works. However, *Hold Still* continues to offer a communal space for people to pause and consider their personal and shared experiences of the pandemic.

We felt it was crucially important to take the portraits back to the communities where they were made, and launched a nationwide community exhibition. The 100 photographs were displayed for four weeks on 400 outdoor posters at 112 locations and 80 towns and cities across the UK, from Glasgow to Southampton. They could be seen on high streets, buildings, bus stops and a special hand-painted mural in Manchester's Northern Quarter. In total, the Gallery estimates that the portraits have been seen by over five million people, and we are very pleased that all 100 images will find a permanent home at the National Portrait Gallery.

We are incredibly grateful to our project partners, Taylor Wessing, who supported the digital exhibition, and the Co-op for making the community exhibition and this book possible. It is fitting that we could produce a publication to mark the project and create a lasting document to remember this moment in our history. We were also delighted that the photographs were displayed together in an outdoor exhibition at the National Memorial Arboretum in Staffordshire, and I would like to thank Philippa Rawlinson, Managing Director, and all the team there for realising the exhibition.

I extend my sincere thanks to the fantastic team at Kensington Palace for their time and dedication in bringing this project to fruition. Thank you to my wonderful colleagues at the National Portrait Gallery, led brilliantly by Denise Vogelsang together with Clementine Williamson, who managed the exhibition and entry process. My thanks go to Léa Aubertin, Julia Bell, Katherine Biggs, Jack Brill, Caitlin Brooker, Sophie Colley, Emanuel de Freitas, Laura Down, Andrea Easey, Kara Green, Samantha Harvey, Sabina Jaskot-Gill, Magda Keaney, Ros Lawler, Francesca Laws, Jessica Litwin, Kevin Madeira, Laura McKechan, Lucy McNabb, Abi Ponton, David Saywell, Alison Smith, Liz Smith, Georgia Smith, Amber Speed, Anna Starling, Emily Summerscale, Sarah Tinsley, Tijana Todorinovic, Helen Whiteoak and Rosie Wilson, who worked tirelessly throughout the year to make *Hold Still* such a success. My thanks also go to North for their work on the design of both the book and exhibitions, in particular Jeremy Coysten, Sean Perkins and Jonathan Leonard.

Finally, I extend my heartfelt thanks to every single person who submitted a photograph. Your images continue to speak of resilience and bravery, humour and sadness, creativity and kindness, tragedy and hope, and have helped to create a unifying and cathartic portrait of life in lockdown. *Hold Still* is an important historical record of this extraordinary moment in our history – expressed through the faces of the nation – that will remain of utmost importance for generations to come.

NICHOLAS CULLINAN
NATIONAL PORTRAIT GALLERY

Outside of our own eyes,
portraiture is the closest representation we have of each other.

We are honoured as judges to experience our
nation at its absolute best in this most challenging of times.

Hold Still has given us the treasured chance to
see through the eyes of people in their most tender moments, into the seconds
flushed with emotion, into the hope caught in a glance, into the loss captured in a
gesture, into this most memorable time of many of our lives.
And there are moments of anger, of loss, of triumph of love or perseverance.

Hold Still is fearless and kind as fearless and kind as
the photographers and their subjects ...
A wilful new born baby kisses their masked mother
through a plastic sheet, a grandmother holds her hand to the window
with her granddaughter on the other side.
A child draws a rainbow. A nurse lost in thought on the
edge of tears in a sterile corridor ...
A policeman hugs his child, who hasn't been able
to hold him, like a soldier coming home ... Family ...

Over thirty thousand of these powerful moments caught in the
digital atmosphere curated and spearheaded by
Her Royal Highness, supported by the judges and exhibited
by the National Portrait Gallery.

Hold Still is a celebration of the human spirit in adversity.

There is not one photograph that does not look at one who is loved.

100 portraits of perseverance inside a pandemic.
When historians look back to this time – and they will –
and ask, 'Yes, but how did the national feel?'

The answer will be, 'Hold Still.'

LEMN SISSAY

HOLD

STILL

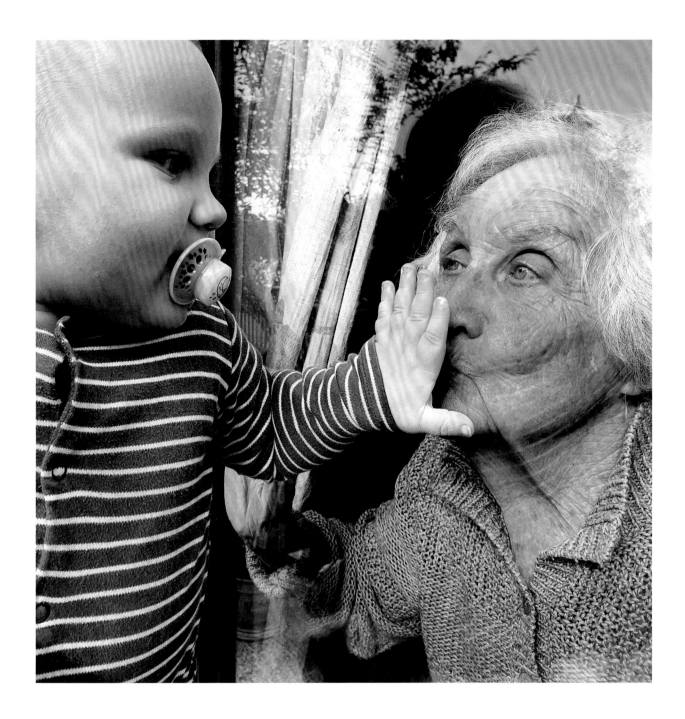

1

GLASS KISSES

BY STEPH JAMES
COWFOLD, WEST SUSSEX

This is a photograph of my 1-year-old little boy and his 88-year-old great grandma, who both miss each other so much at the moment. I captured this beautiful moment between them whilst dropping off groceries. Kisses through glass.

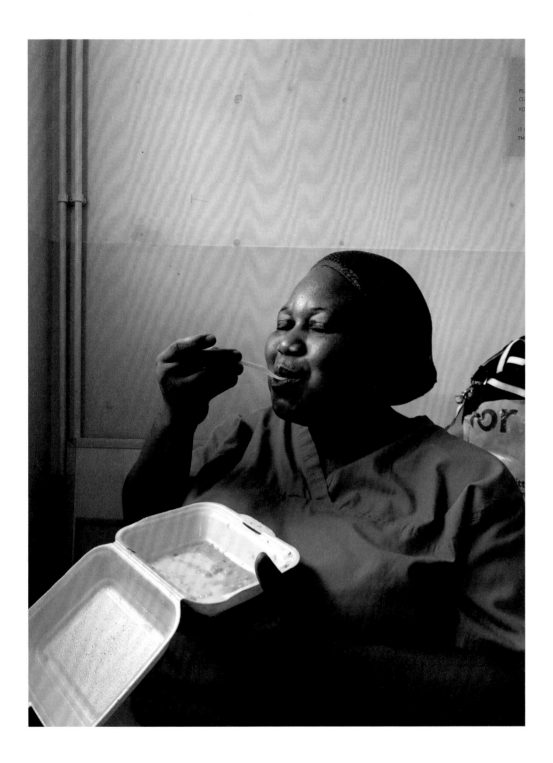

During the peak of the pandemic, I signed up to work as a cleaner in a COVID-19 ward at my local hospital, Whipps Cross. Within days, Gimba, our ward host, called me 'my son'; I noticed she loved eating rice. Gimba migrated from Nigeria to Britain and has been working at the hospital for over a decade, commuting for two hours to get to work.

On the day the photograph was taken, Gimba had received the terrible news from Nigeria that her mother had fallen ill and had been rushed to hospital. Gimba cried all day and was heartbroken that she couldn't fly home to see her mother and look after her because of travel restrictions during the pandemic. She declined to take any time off, saying: 'I have to feed my patients'. I took this photo while Gimba was having lunch in the staff room, after preparing meals for all eighteen COVID-19 patients in our ward. She was having chicken and rice.

2

GIMBA – THE WARD HOST

BY HASSAN AKKAD
LONDON

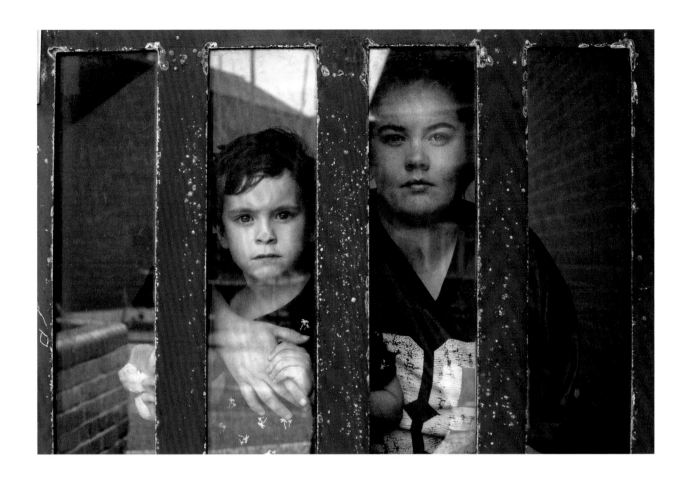

3

AMANDA AND HER SON TERRENCE

BY ZAK WATERS
FOLKESTONE, KENT

During lockdown, it was pretty much me and my son, as my partner worked days and days on end. We live in a communal flat block on the very top floor. The front door is almost locking us away from the world, and when we went out we felt almost free – free from being 'locked' in and free from lots of schoolwork! I've felt more anxious than I ever have before. My stress levels rocketed. Home-schooling was difficult, but our bond became really strong as we were in this together.

4

RAINBOW REFLECTION

**BY H. DE KLERK
(AGED 14 YEARS)**
HERTFORDSHIRE

A rainbow is an arch of colour, visible in the sky, caused by refraction and the reflection of the sun's rays on water droplets. Seven vibrant colours make up a rainbow and each one is unique. Rainbows have been placed in the nation's windows to show solidarity with those key workers who are putting themselves on the frontline while tackling the effects of COVID-19. Key worker jobs are varied, just like the vibrant colours in the rainbow. Each individual is unique but when we work together, we convey a message of inclusion, hope, promise and peace. Diversity is beautiful.

The lockdown period also provided the opportunity for people to slow down and reflect on life. It was a time for individuals to explore and examine how their perspectives, attitudes, experiences and actions all colour their thinking. Finally, rainbows are a symbol of promise and offer the hope that the troubles of today will pass – hold onto your faith, and time will bring fresh new beginnings!

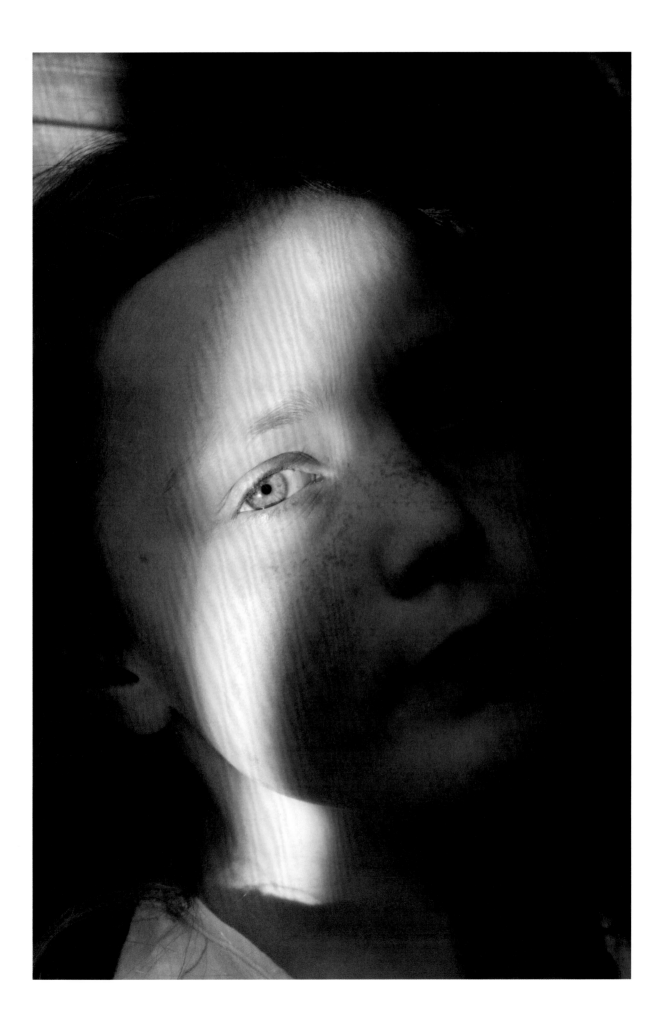

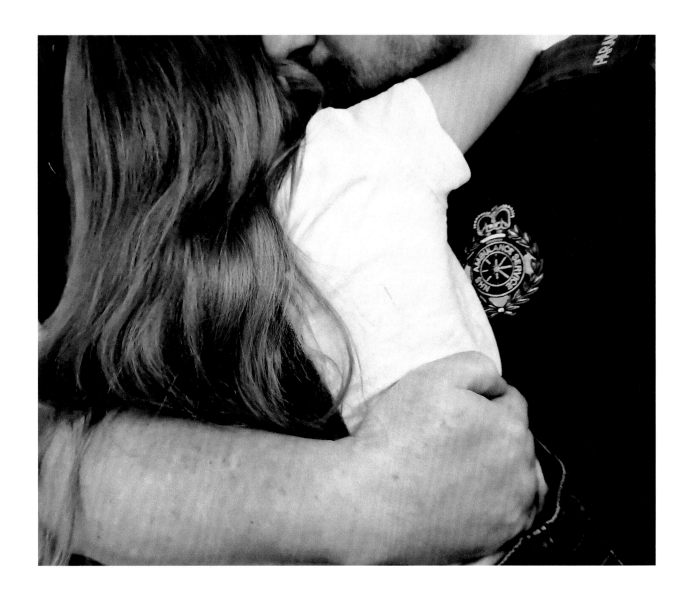

5

BE SAFE DADDY X

BY CERI A. EDWARDS
NEWPORT, SOUTH WALES

This picture was originally a piece of work set for our daughter during lockdown. Poppy struggled with her dad having to go to work as a paramedic throughout the COVID-19 pandemic, and she worried about him each time he left to go to work. Poppy loves a cuddle and this happened to be a special moment between them just before my husband left to go on a night shift.

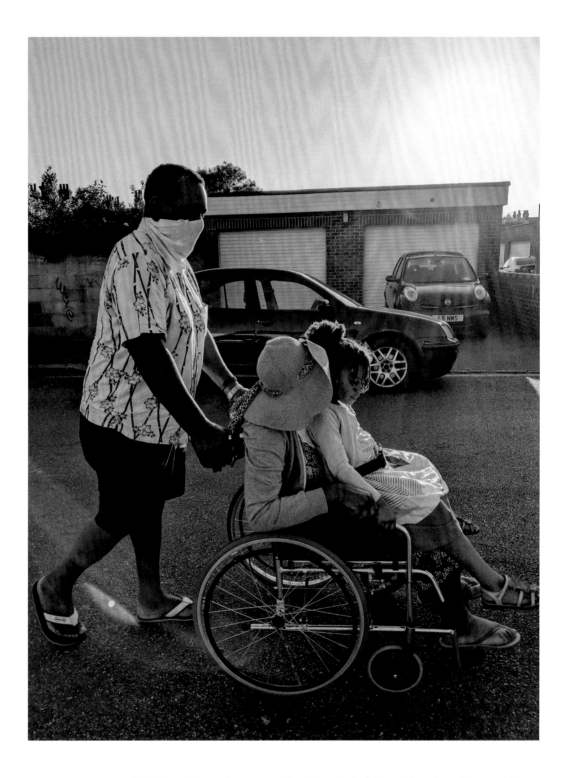

GRANDMA + GRANDAD = LOVE

BY DIANE BARTHOLOMEW MAGALHAES
GRAVESEND, KENT

This is a picture of my mum (Constance), dad (Dennis) and my 4-year-old daughter (Maliha). My husband Edilson and I moved to the area from London just before lockdown. My parents were our first socially distanced visitors. They had spent weeks self-isolating and, in the excitement of having a bit of freedom, they forgot their face coverings – what they are wearing are actually home-made masks! I feel that this image represents love, unity and a bond between grandparents and their grandchild. What also resonates is that children are adaptable, whether it's seeing Grandma in a shiny new wheelchair for the first time, being off school for an unexpected extended period or the suddenness of life during, and after, the pandemic. This is their new normal. And to an extent they have accepted it. I hope that I have captured a stillness in this picture that quietly reflects the mood of a nation.

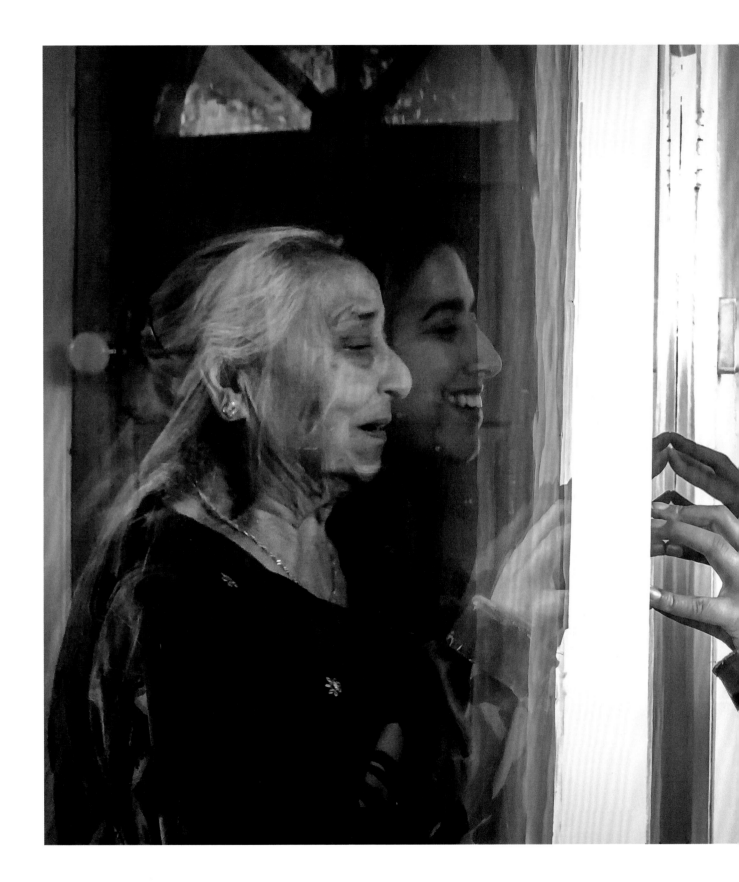

DADI'S LOVE

BY SIMRAN JANJUA
LONDON

This photograph, taken on 20 June 2020, captures love and connection during lockdown. It shows my sister-in-law and her grandmother (*Dadi* in Punjabi) meeting after months of being apart. In this moment I felt the depth of love they feel for each other, capturing both the joy and longing in their eyes; separated by a window, but connected by love.

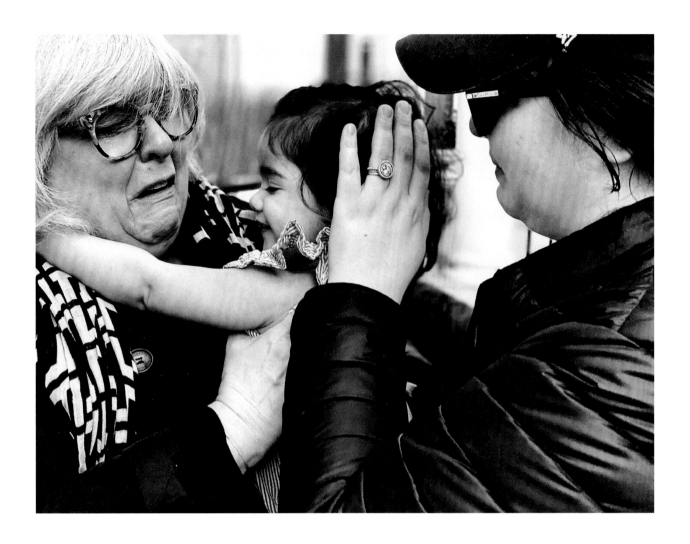

WHERE'S GRANDPA?

BY RONI LIYANAGE
LONDON

This photograph captures the moment when my daughter Gaby – together with her mother Vanessa – could embrace her grandmother Teri for the first time, a month after her grandfather Kevin FitzGerald died from idiopathic pulmonary fibrosis (IPF) at the Royal Brompton Hospital on 19 April 2020. 'Where's Grandpa?', they whispered as they cried. Then Gaby, without hesitation, smiled and pointed to the trees outside the window where he had spent his last weeks, comforted by the view of St Mary Abbots Church, where he had been baptised sixty-six years earlier. In this time of social distancing and lockdown, it is a hug between three generations collectively mourning the loss of a grandfather, father and husband.

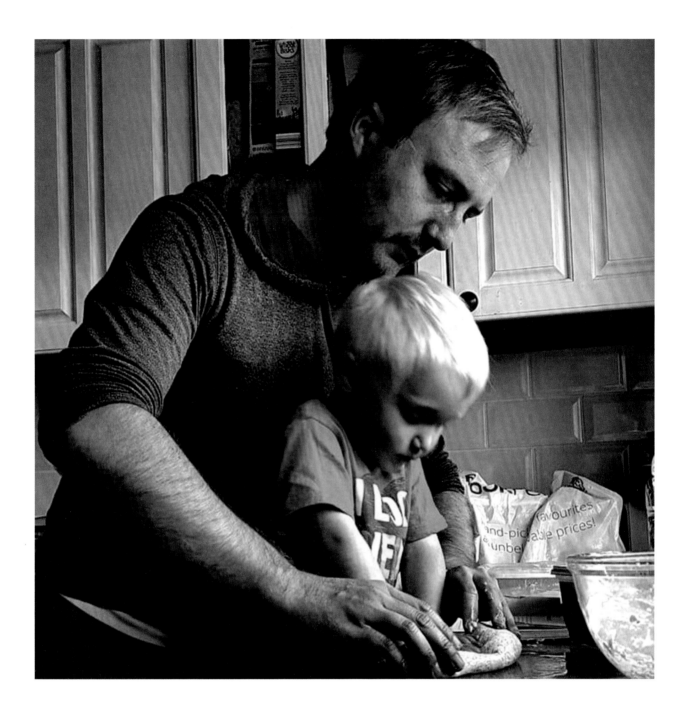

9

MAKING BREAD

BY JAMES WEBB
COLNE, CAMBRIDGESHIRE

This is me and my son Jake making bread together. Baking was something that I enjoyed but didn't get to do very often. Lockdown gave me the opportunity to bake and enjoy this passion with my children. During this time, we started off making flatbreads, cupcakes, muffins and the like, and then moved on to bread. Baking became a daily pleasure we were all able to enjoy together. We've continued to bake as a family and my children have enjoyed learning how to knead dough and the process of proving before baking. Making bread has become the new normal in our house and is a hobby now enjoyed by the whole family.

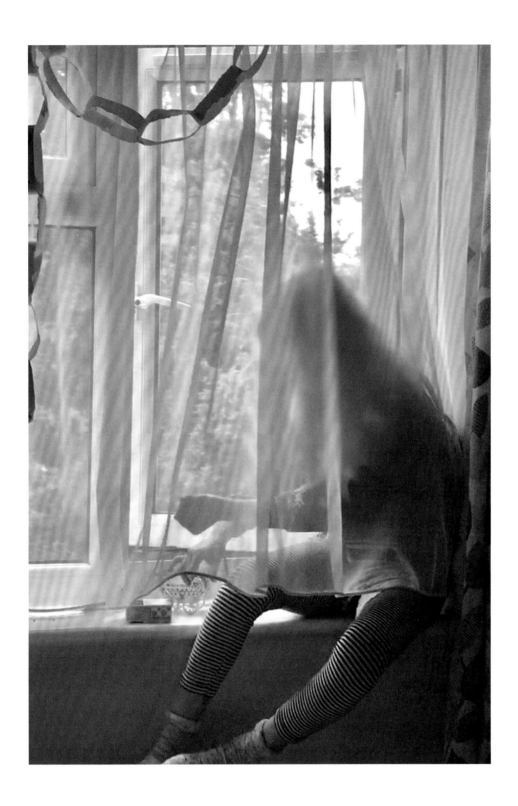

10

LOSS OF LIFESTYLE NOT OF LIFE

BY N
UK

We are victims of domestic abuse, living in a refuge. My child is trying to cope with the loss of her lifestyle, pets, school, friends, activities along with the COVID-19 isolation and missing the hugs of family. Yet ... she has made cards for the elderly to encourage them to keep smiling and keep safe. This child is my spirit light. My daughter was sitting and playing with her toys on the window sill, window open, looking out.

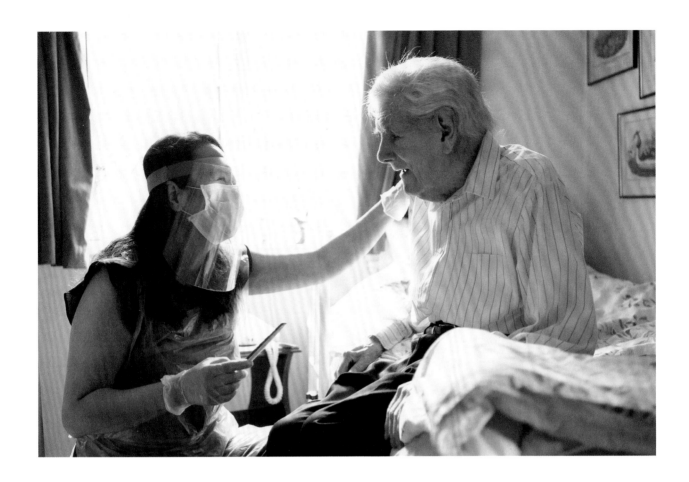

11

CARE WORKER

**BY KARWAI TANG AND
FABIANA CONNORS**
ELSTREE, HERTFORDSHIRE

Karwai writes, 'As a photographer, I had the privilege of being given the opportunity to follow a care worker visiting a client during the pandemic. They do an amazing and underrated job, and I wanted to highlight this. I felt this image captured the compassionate side of caring. Fabiana, who cares for Jack, was with him in his room.' She says, 'I care for him and he makes me happy in these terrible times. The first thing he says to me when I open the door is, "I am so glad to see you", and with that he makes all the hard work we have been doing worthwhile. With the lockdown, there can be no family visits, so we are the only people he sees all day. It is my job to make him feel better, even if only for a few minutes, to make sure he is clean, fed and has taken his medication. I make sure to make a few little jokes to make him laugh a bit. I love what I do, I love my job, I love caring for the elderly.'

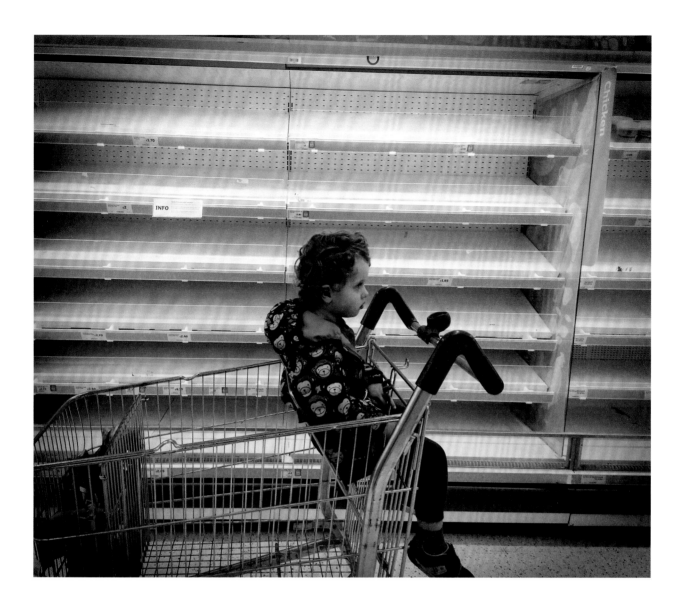

EMPTY

BY JULIE THIBERG
HITCHIN, HERTFORDSHIRE

This was taken just before lockdown happened, when I took my son shopping. I happily got a big trolley and was surprised at how easy it was to get a parking space, only to find the Sainsbury's superstore completely empty – only a few oils, spices, clothes and toys were left. My son Leo had just turned 3 years old and didn't understand what was happening at the time, although he did pick up that our shopping trip was very different on this day. As a parent, I probably experienced silent panic and a fear that this type of shopping would be the new normal. I decided to take the picture to remember a unique day that would be the start of a long and challenging time. We had been to pay for our wedding ceremony, although we were realising it was unlikely to happen, so walking into an empty shop only made us more worried. I look forward to telling Leo all about this time when he's a lot older.

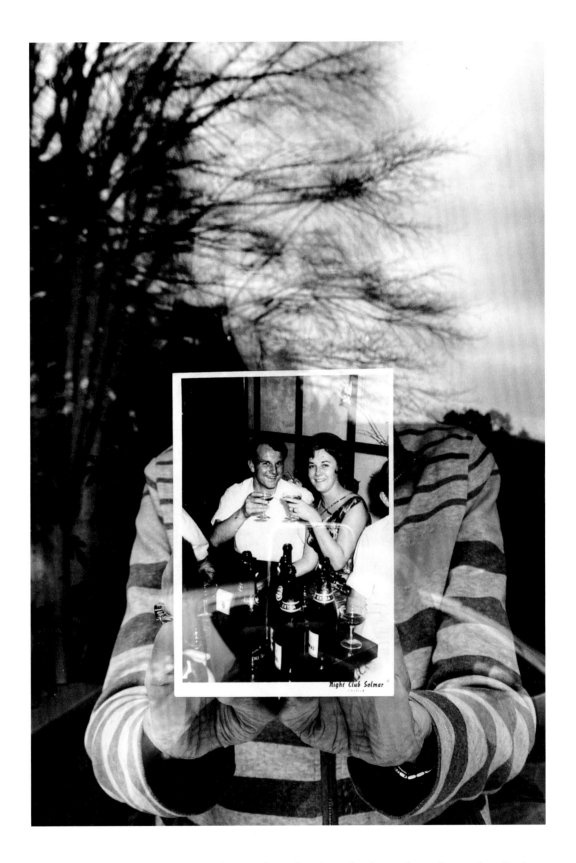

THROUGH THE WINDOW

BY CLAUDIA MINCHIN
CHESTER, CHESHIRE

This photograph was taken a few days after I came home from university due to the pandemic. I was visiting my grandma whilst keeping a safe distance, which felt strange because we always used to hug when we saw each other, especially since I've been at university and those times are more scarce. I took this impromptu photograph while she showed us some old photographs she had found recently. This one of her with my grandad in Calella for their honeymoon in 1964 stood out for me.

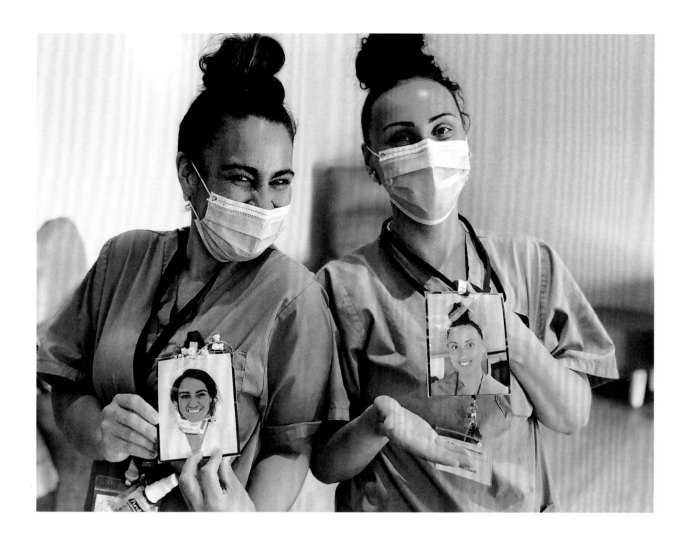

WE ALWAYS WEAR A SMILE

**BY JILL BOWLER AND
TREVOR EDWARDS**
PRESTON

We always want our residents at our dementia nursing home to know we are smiling under our masks. Jill, our activities coordinator, took this picture as we wanted to show not only our smiling eyes but our friendly faces too. Beth and Sade are in the photo and are fantastic carers, and we are all so proud of how we have all adapted to make the whole of our smiles visible through the masks. We have had to learn new ways to communicate with our residents during the pandemic as the mask is so restrictive and that comforting smile has been hidden. We all still smile and want it to be as visible as possible.

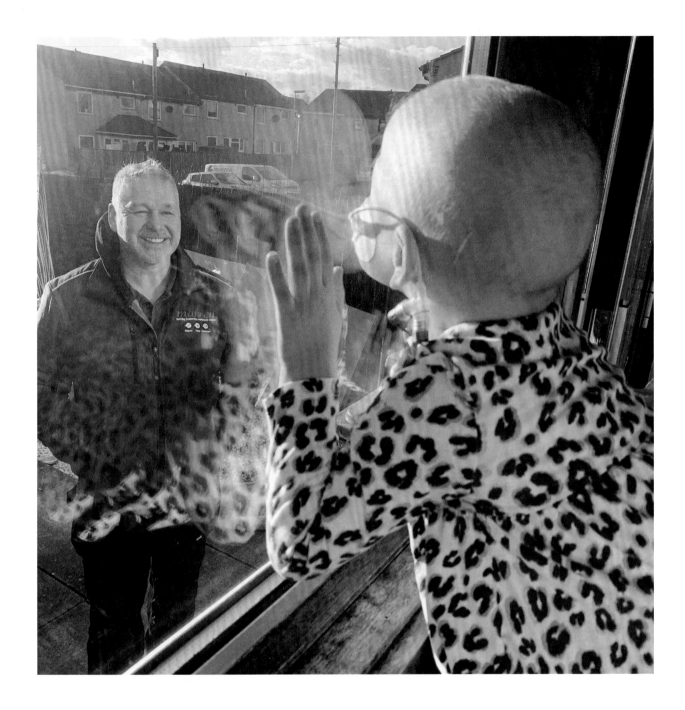

SHIELDING MILA

BY LYNDA SNEDDON
FALKIRK

We took the decision as a family to isolate Mila at home with myself in the week prior to lockdown. After trying to find an alternative solution, we took the difficult decision to isolate in different households to protect Mila, who at this point was only four months into her chemotherapy journey for acute lymphoblastic leukaemia. As Mila's dad Scott had to continue to work and her big sister Jodi was still attending school, we could not risk the possibility of infection being brought home, so they would visit every day at the window. At first Mila did not understand why Scott could not come inside and would ask him, 'Why can't you come in Daddy?' This photograph was taken on the first day of separation. Following seven weeks of temporary separation and after being furloughed from his job, Scott was reunited with Mila. Looking back, I'm so proud of my daughter and how far she has come; the level of resilience Mila has shown during this unprecedented time is truly remarkable.

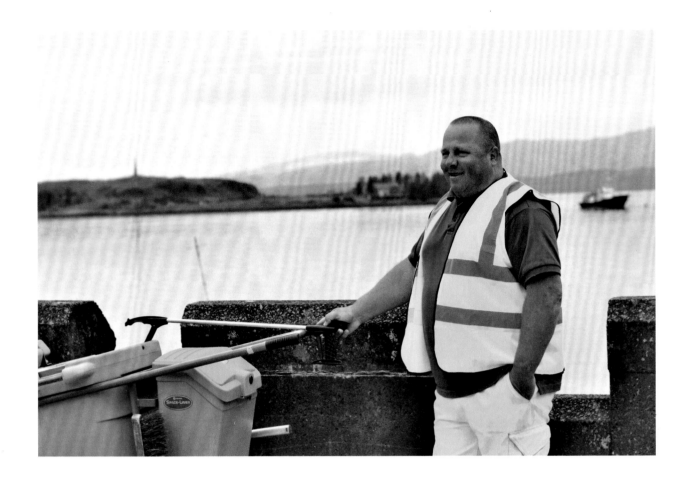

16

ESSENTIAL

BY CHRISTOPHER COX
OBAN, ARGYLL AND BUTE

This was the first time I had been out for seven weeks and what struck me most was how friendly and happy everyone was. Strangers were keen to stop and chat to each other. This Oban street sweeper was carrying out essential work, but had time to pass the time of day.

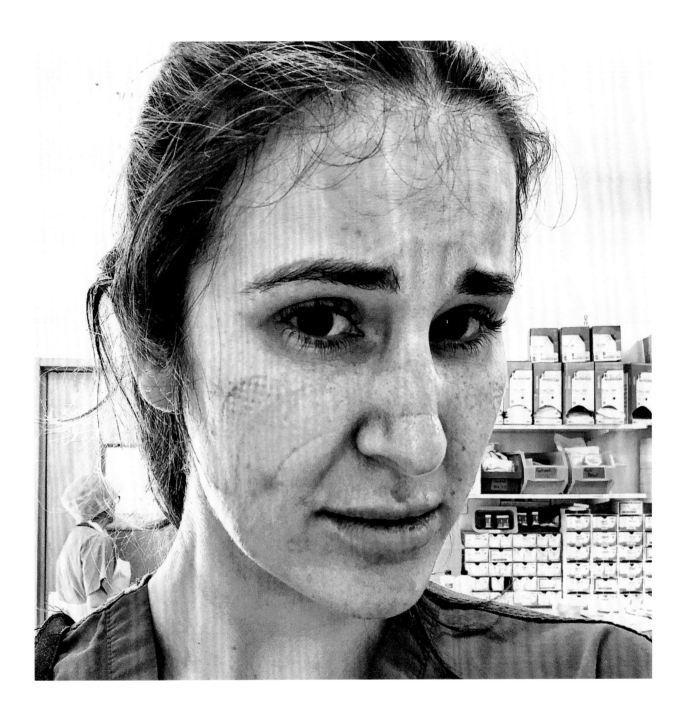

17

THIS IS WHAT BROKEN LOOKS LIKE

BY CERI HAYLES
BRIDGEND

This is what broken looks like. This is operating for three hours in full PPE. This is dehydration. This is masks that make your ears bleed because the straps have slipped and you daren't touch them. This is fighting an invisible enemy that becomes more visible each day. This is a face I never thought I'd show the world, but one that I wear more and more. I took this photo to have as a reminder of how far I'd been capable of pushing myself when I needed to. I sent it to my family to tell them what a hard day it had been and they were all so shocked by it. The person they know as being so well put together, always wearing a smile, was not the person they saw that day. Looking back on it now, I feel immensely proud of the commitment shown by myself and my colleagues to provide safe care for patients, even in the depths of a pandemic. We still wear full PPE for all of our cases, and you never get used to it, but I know we'll keep doing it for as long as it is needed.

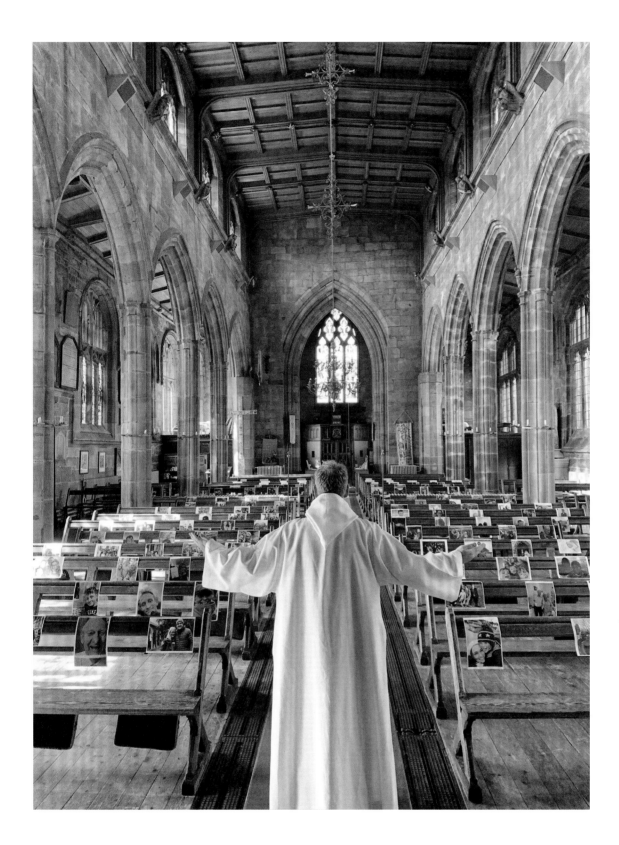

**PRAYERS FOR OUR
COMMUNITY**

**BY THE REVD. TIM HAYWARD
AND BETH HAYWARD**
BUNBURY, CHESHIRE

When it was announced church buildings were to be closed to the public
in order to reduce the transmission of the virus, I wanted to assure our
community. Although we couldn't gather physically, their photos in church
were a symbol that they and their loved ones were still very much in our
thoughts and prayers.

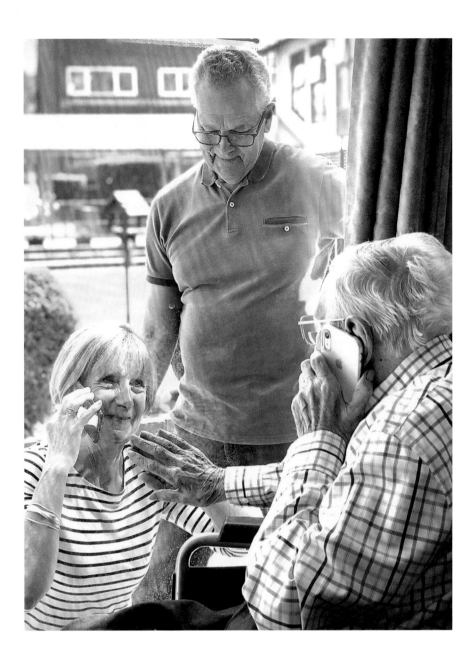

This portrait was taken by Kris, the clinical lead in the care home where Phil lived. Kris took the photograph for Phil's daughter Sue, who submitted the work. Sue said: 'As I approached the window, my father's smile lit up the world. Probably belying the fact that he couldn't really comprehend why, after normally frequent visits and companionship in his twilight years, his daughter hadn't been allowed to visit for the last three weeks. Easter Saturday 2020 and these precious, intensely emotional moments, will stay with me forever. One week later our wonderful dad, grandad and great-grandad passed away peacefully. I can never fully express my gratitude to the carers who, sensing the situation and having looked after my father with love, care and compassion for seven years (as well as my mother for three of those years), made those moments possible.'

Kris explains: 'We devised a plan for Phil to see his daughter Sue via a glass wall and communicate using mobile phones. Hearing our plan gave Phil a burst of energy to go in his wheelchair, hold a muffled conversation, reaching over to put his hand on the glass wall, convinced that he was touching Sue. Struggling to speak but hearing Sue made him so very happy. Their expression of emotion through tearful, smiling eyes and touching hands; the entire conversation was just one amazing moment!'

19

LAST PRECIOUS MOMENTS

BY KRIS TANYAG AND SUE HICKS
CHICHESTER, WEST SUSSEX

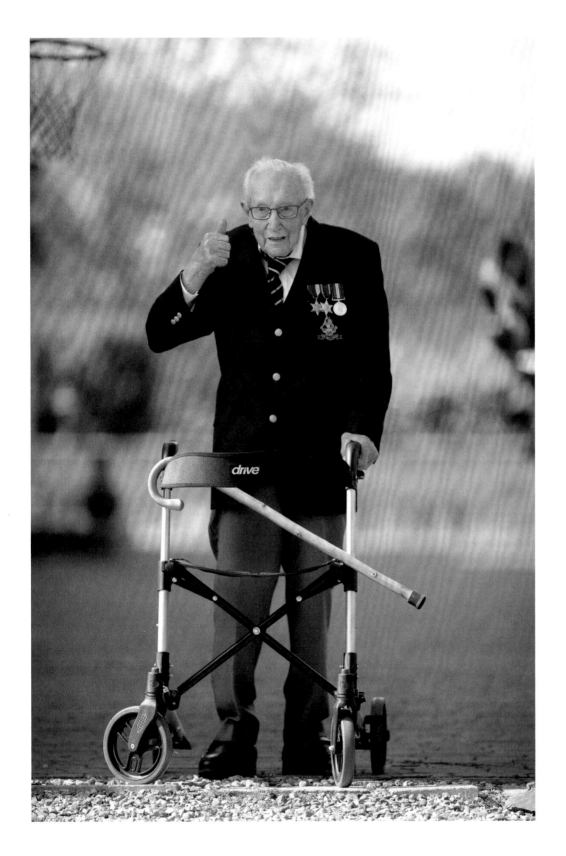

20

CAPTAIN SIR TOM MOORE

BY TERRY HARRIS
MARSTON MORETAINE,
BEDFORDSHIRE

Captain Sir Tom Moore completed 100 lengths of his garden before his 100th birthday to raise money for NHS charities. Having captured the public's imagination, the total he eventually raised was almost £33m. In recognition of his achievement, Moore was given the honorary title of colonel on his birthday and was awarded a knighthood by Her Majesty The Queen, which was bestowed on him at a special outdoor ceremony in the grounds of Windsor Castle in July 2020.

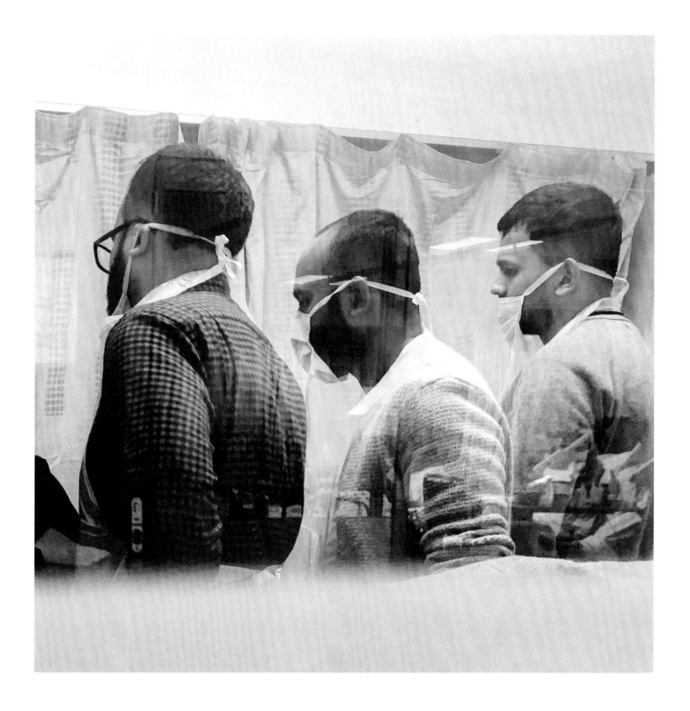

HEART BROKEN

BY KAMRUL HASAN
LONDON

This was taken on the saddest day of our lives when our father died on the 22 March 2020. This was on the night of his death. We'd had a tough two weeks leading up to his death, with the nurse and doctors giving us the worst news – that our father wasn't going to live. He died of pneumonia.

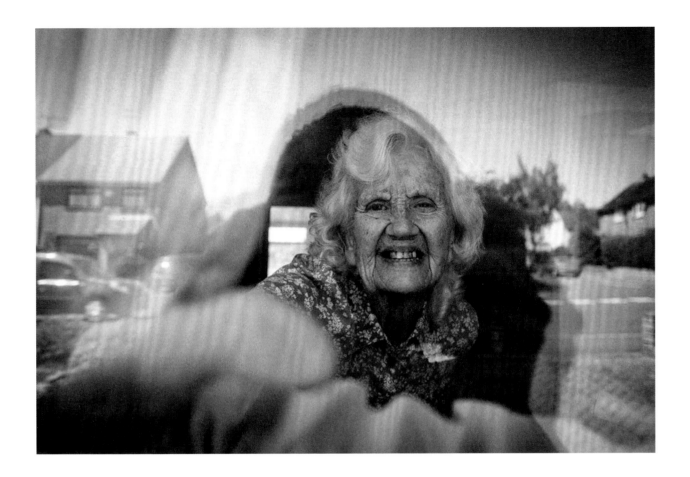

**'KEEP SMILING THROUGH.
JUST LIKE YOU ALWAYS DO.
'TIL THE BLUE SKIES DRIVE
THE DARK CLOUDS FAR AWAY'**

BY JESSICA SOMMERVILLE
ROTHERHAM,
SOUTH YORKSHIRE

This is my darling Nan, my ray of shining light. She raised me to be strong and kind. I took this portrait when I wasn't allowed in the house. Her smile was still bright, even though I hadn't been able to cuddle her for months.

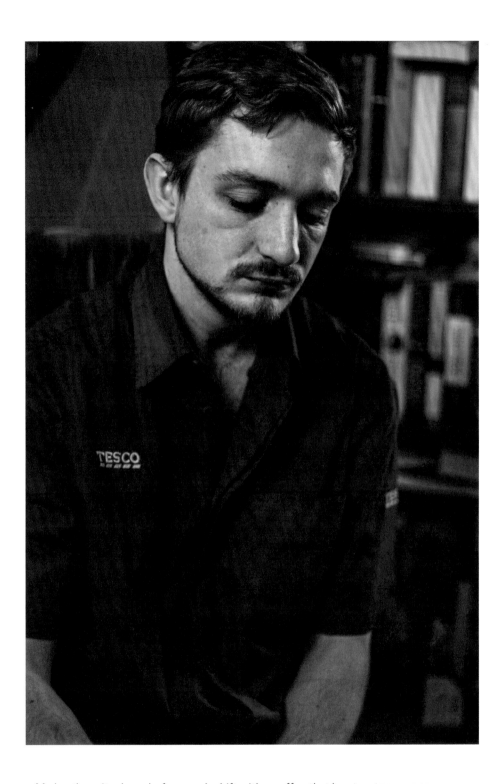

My brother sits down before each shift with a coffee that has two teaspoons of honey in. He walks between 18,000 and 30,000 steps every shift and is on his feet for more time every day than I am in a fortnight. He has been working twelve- to fourteen-hour night shifts up to seven days in a row at our local supermarket. I do not think he envisioned this when he started his role in the summer of 2017. Then again, nobody did. What began just as a part-time job to supplement his income during university has now become an essential role for the functioning of our small town in west Wales. Despite already graduating, he feels compelled to give everything he has got to keep the store running, even if it means he spends his days off just trying to catch up on sleep. As the weeks crawl by, I can see the dark lines under his eyes becoming more permanent.

23

JUST ONE MORE NIGHT SHIFT

BY ANGHARAD BACHE
ABERYSTWYTH

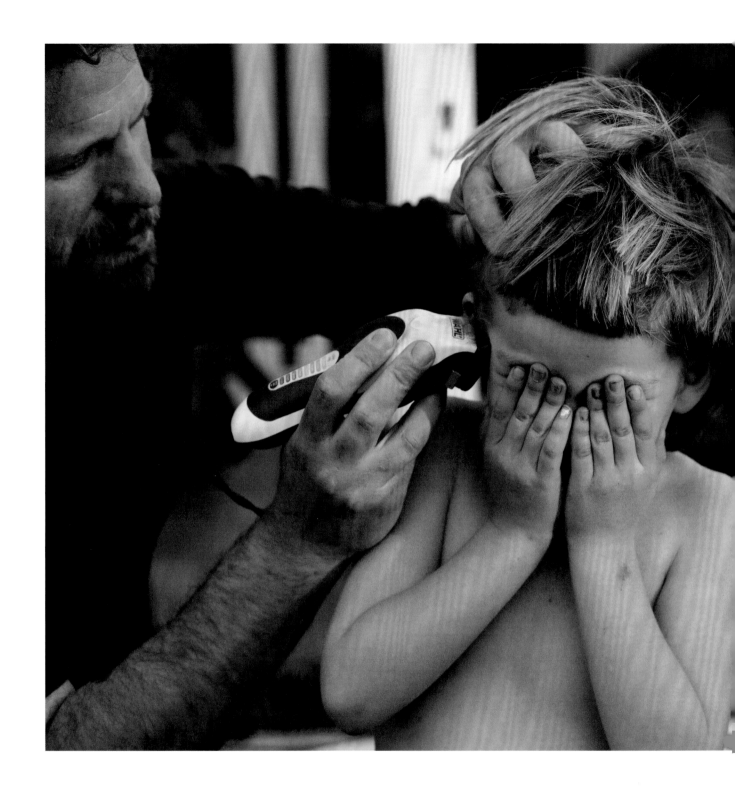

24

HOME HAIR

BY KARNI ARIELI
BRISTOL

In this image are my 6-year-old Teo and his dad, mid-haircut, at home in Bristol. I loved watching as Saul gently shaved the sides of his hair, my son's fingers still with nail polish on from other adventures. My kid was a little fragile and scared of the little hairs and the machine ... but the connection is tender and strong. The photo shows such a small moment with big meaning and emotion. For me, as a mother and artist, photography has been a friend and saviour, helping me to create, document and digest in these challenging times. I'm grateful for that. All is love 2020.

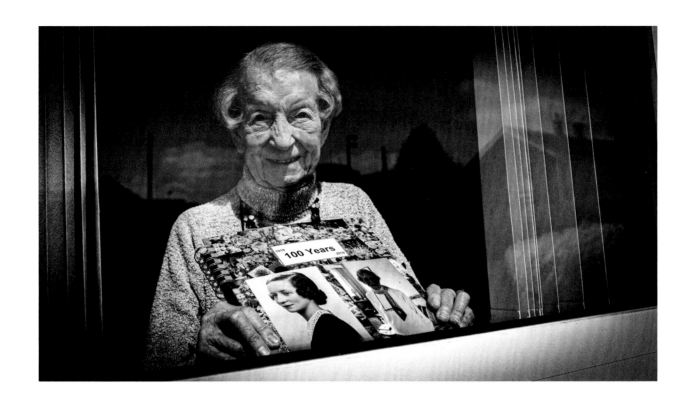

BEHIND THE GLASS

BY LYNDSEY ADAMS
THORPE AUDLIN,
WEST YORKSHIRE

Mrs Fogg stood weekly, behind the glass, and united with the village to clap for our heroic NHS and key workers as they battled the pandemic. A steadfast and prominent member of the village, Mrs Fogg is a lady who devoted her life to caring for others. She continued to show pride for her previous work and colleagues every Thursday during lockdown. Her own beauty and resilience shone through during her 100th birthday year. As part of the celebrations, a memory book was presented to her by her family to capture her wonderful life. During the commemorations of VE Day, we quietened our hearts and stood in silence for Mrs Fogg and all others who served to give us the life we know and love today. As Mrs Fogg was at her window, I asked if she would share her memory book photographs with me. She happily obliged, and there we stood, at either side of the glass, viewing her life in pictures. Before I returned to the confines of my house, I asked to capture this special moment with my tremendously inspirational neighbour.

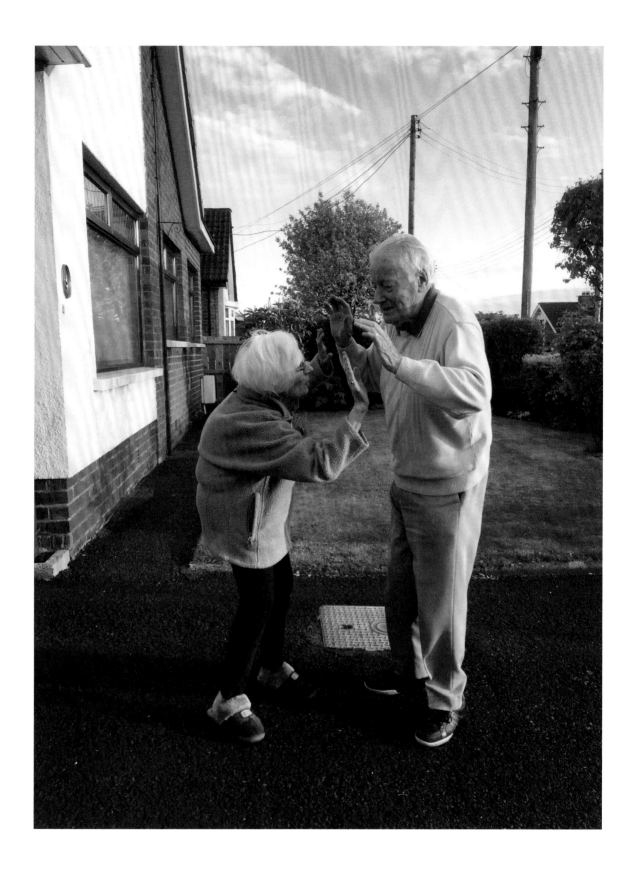

26

CLAPPING TOGETHER FOR THE NHS

BY TRICIA GILMORE
BELFAST

I took this photo of my next door neighbours, Gladys and Jack. Jack is in his nineties, and they both came out every Thursday to clap for the NHS. They are an inspirational couple and still very much in love. They encouraged others to come out and clap and waved to everyone in the street. They are lovely neighbours to have and I am lucky to live next door.

27

THANK YOU

BY WENDY HUSON
LIVERPOOL, MERSEYSIDE

Our little girl, Amelia, has Down's Syndrome and raises a lot of positive awareness on social media under Amelia May Changing Attitudes. On the 12 May 2020 I (mummy) made Amelia a very simple nurses outfit and then took the picture in our kitchen to celebrate International Nurses Day. Amelia's aunty and cousin (mother and daughter) are both amazing nurses and Amelia has seen a lot of nurses in her short life. Therefore, we wanted to put a special post on her social media accounts recognising International Nurses Day and thanking all of the nurses for the amazing work they do every day and especially during the COVID-19 pandemic (throughout which Amelia has been shielding). A couple of Amelia's followers on her Facebook page suggested that we submit the photo to the *Hold Still* project, which we did. We had no idea that such an innocent photo would be picked out of so many to be included in an exhibition that will go down in history. This is amazing for us and the Down's Syndrome community.

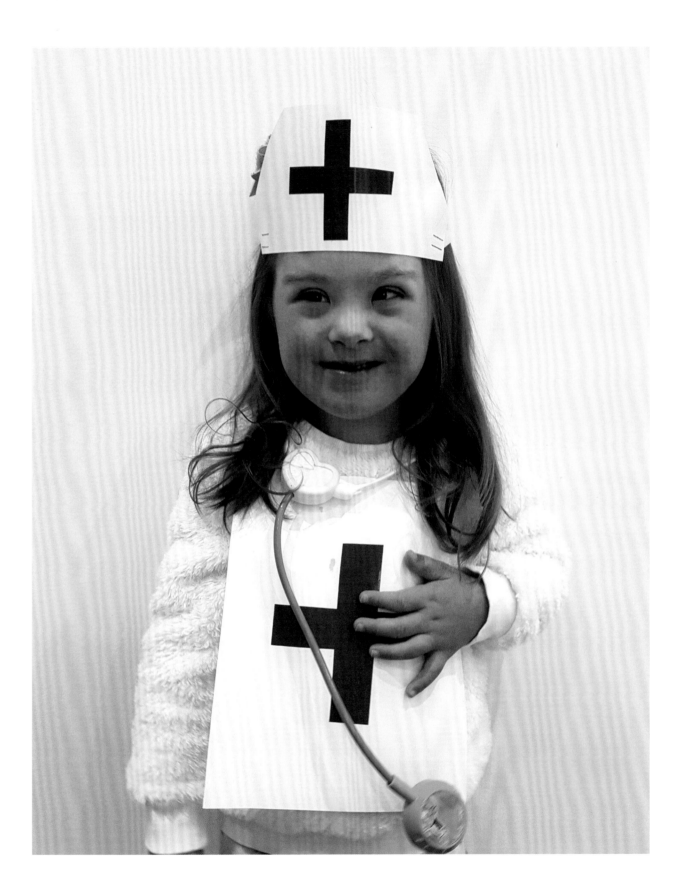

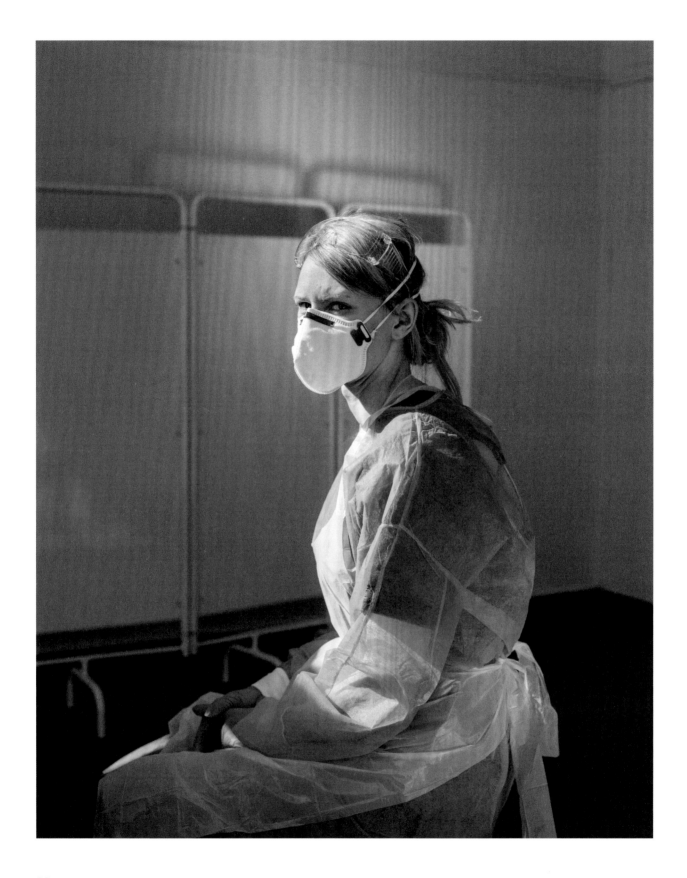

MELANIE, MARCH 2020

BY JOHANNAH CHURCHILL
LONDON

I took this photograph of my colleague Melanie wearing PPE in clinic. We are both nurses working in south west London. She had been readying essential infection control procedures for the opening of the COVID-19 clinic that week.

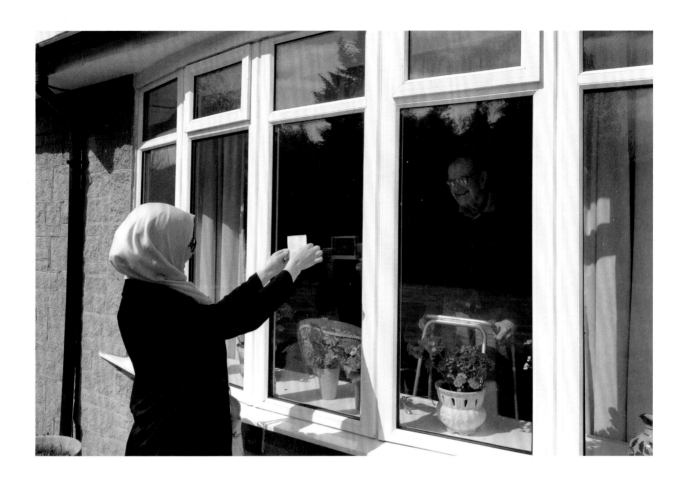

GENERATIONS APART

BY JULIE AOULAD-ALI AND
KAMAL RIYANI
WILSDEN, WEST YORKSHIRE

The photograph was taken by my son-in-law, Kamal. My daughter Sarah is expecting her first child and had just had her twelve-weeks scan a few days earlier. Sarah and my son-in-law drove from their home near Manchester over to my parents' house in West Yorkshire, just so they could show her grandparents the scan photograph. Both her grandparents are in their nineties and were shielding, so they had not seen anyone other than carers since the lockdown began. The look on my dad's face says it all – he looks so happy; it brings tears to my eyes every time I look at this photograph.

RAINBOW

BY HELEN PUGH
EDINBURGH

Ten days into shielding, my daughter and I joined the movement to paint rainbows on the windows. It was a moment of hope, fringed by fear and uncertainty. We were holding our breath to see what would happen. My daughter was shielding due to a rare genetic condition, and I'm her sole parent, so lockdown was very quiet for us. In early March, my income as a photographer was lost, as jobs were cancelled and enquiries stopped coming in. We fell through the gaps for financial

help from the government. I carried on taking pictures of my daughter, trying to process what was happening. This image is one of hope, but, looking back on it, I can feel strongly the sense of worry and uncertainty of that time: knowing that, due to shielding, I would be unable to work for months and the worries over my daughter's health. Lockdown was hard for our family, but the rainbow in the window stayed for months and kept reminding me to keep going.

31

THE FIRST KISS

**BY ALI HARRIS AND
LEIGH HARRIS**
LINCOLN

This is the moment that our third baby boy came into the world, in the middle of a pandemic, surrounded by medical staff in full PPE. The first thing he did was try to give his Mummy a kiss through the protective screening and Mummy's mask. This beautiful moment was captured by Daddy, Leigh; it was love at first sight for all of us and we have been besotted ever since. Despite everything going on in the world, children and babies in particular have a way of keeping us grounded and focused (most of the time). We are so proud to have brought a new life into the world during the height of this pandemic.

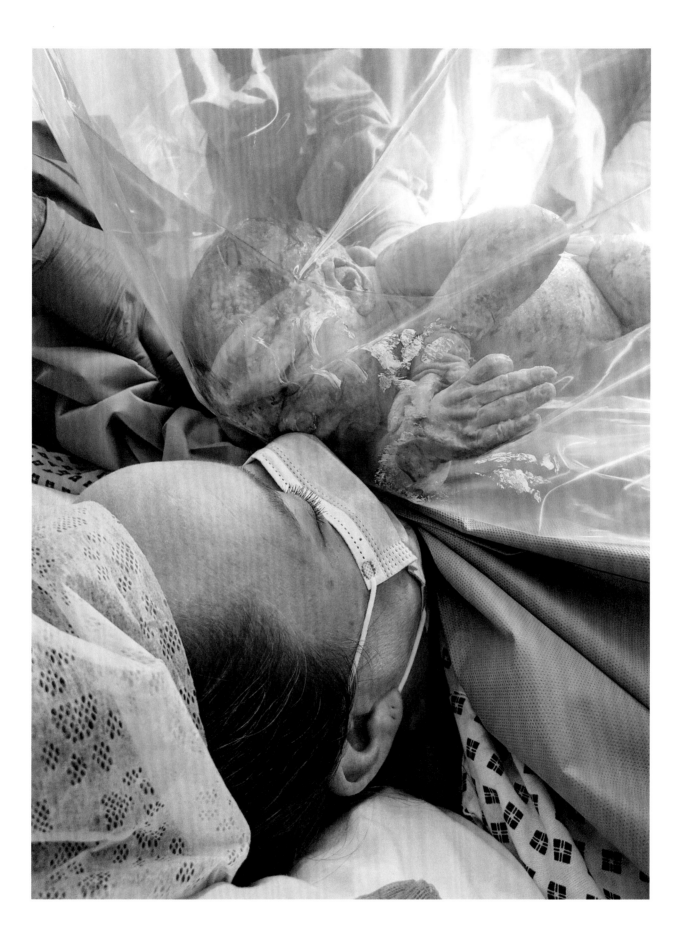

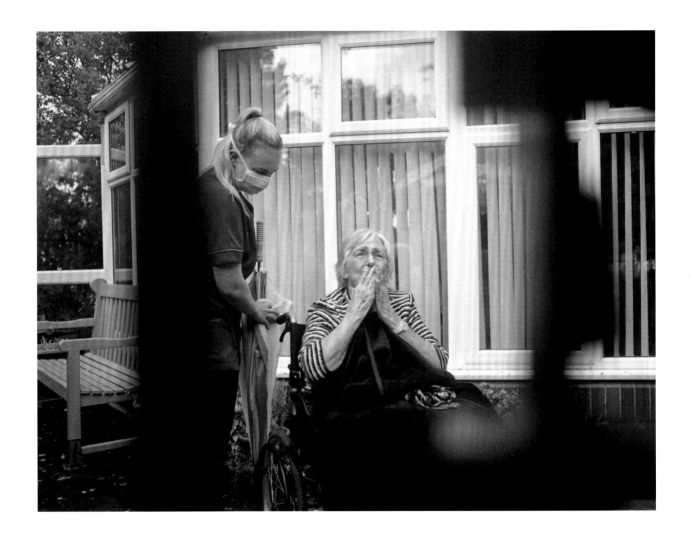

32

GRANNY'S 90TH

BY GEORGIA KORONKA
CHICHESTER, WEST SUSSEX

My granny moved into a new care home for people with dementia on the first day of lockdown. She had come from hospital, so for the first seven days she was isolated in her room and for the next six weeks she saw only unfamiliar faces in the carers and other residents. Every few days we'd Skype call, but often it only distressed her more by reminding her of the outside world she was missing. On her 90th birthday, we drove to the care home and sang 'Happy Birthday' through the locked car park gate. We made presents for her but had to explain that she couldn't touch them for 24 hours. She cried and blew us kisses when we left. Thanks to the incredible carers, her condition doesn't seem to be getting worse. They've been so kind to her and do everything they can to ease her already extreme anxiety. She's been through struggles before, though, and seems to steel herself against it. Granny hardly remembers that day – she's gone from planning her 91st to boasting that she's 100.

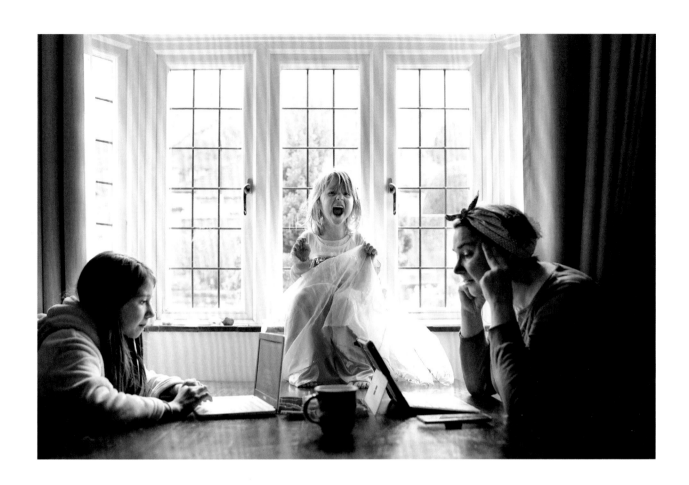

33

HOME-SCHOOLING GOING GREAT

BY ANIA WILK-LAWTON
CROYDON, LONDON

Trying to work and home-school when you have a 3-year-old and an 11-year-old is an exercise in tuning out the noise. One might say, 'Let it go...' Taken in our home, at the multitasking table.

34

BIBA BEHIND GLASS

BY SIMON MURPHY
GLASGOW

This work shows my daughter photographed behind a glass door during lockdown. A quiet moment from a 10-year-old girl's view of lockdown.

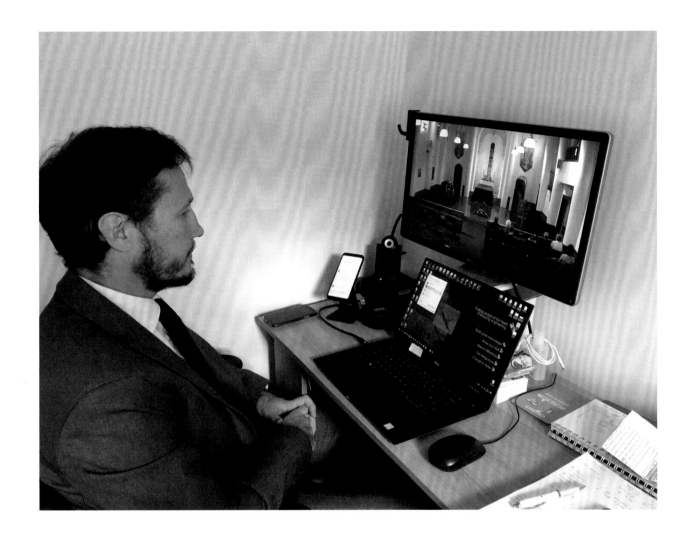

35

FUNERAL HEARTBREAK

**BY BONNIE SAPSFORD AND
FIONA GRANT-MACDONALD**
COCKERMOUTH, CUMBRIA

My brother, Barry, lives in the Lake District and could not travel to be with his family when our beloved Gran died of COVID-19 on 3 May 2020. Her cremation took place on 13 May in Edinburgh with only eight people in attendance. Barry had to watch it live online, but we were so proud he suitably dressed for the occasion. His wonderful partner Bonnie took this powerful picture and sent it on to us. The family all missed him greatly and our hearts were shattered at the realisation that our grandmother's first grandchild could not be with her on her final resting day.

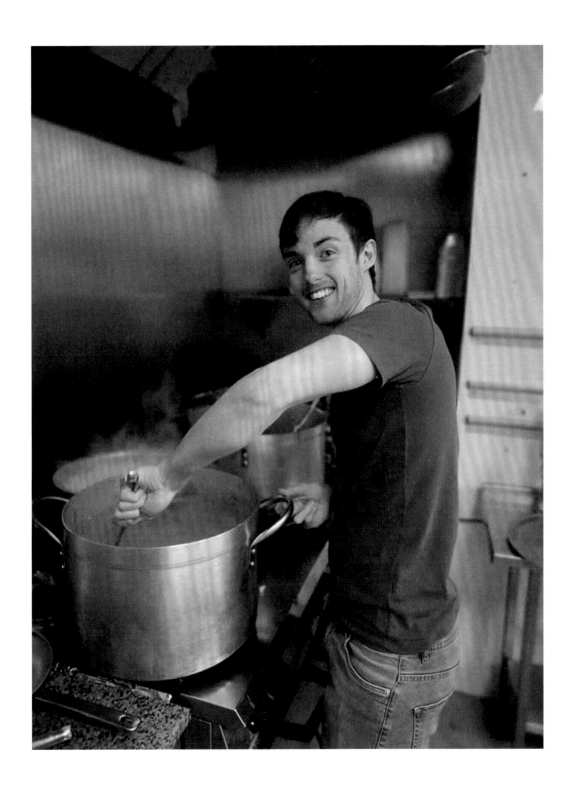

FEEDING THE VULNERABLE

BY ALEXANDRA BEELEY
MIDDLETON,
GREATER MANCHESTER

As the owner of Antonio's Italian Takeaway in Middleton and San Giorgio Italian restaurant in Mossley, Anthony Owens utilised his supply chains and kitchen to make meals for the vulnerable in society who may have found getting their own supplies difficult due to isolating, childcare or being out of work. With the help of his staff, who volunteered their time, these meals were delivered to members of the community entirely for free. In total across two sites, over 2,000 meals were delivered to the vulnerable in Middleton, Mossley and surrounding areas. Pictured is Anthony's cousin, Declan.

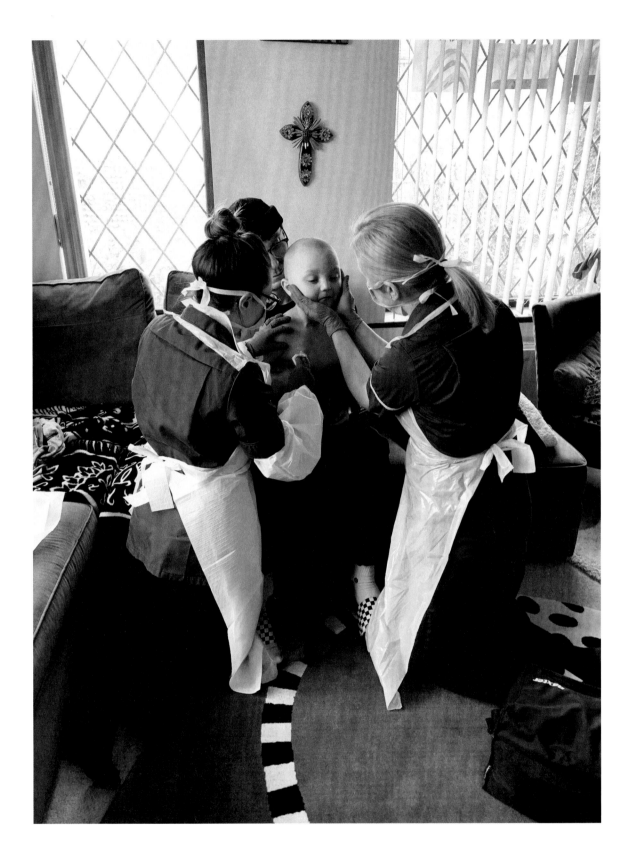

37

FRANCK'S FIGHT

BY ANNA HEWITT
BRISTOL

This shows our 5-year-old son Franck, who is being treated for acute lymphoblastic leukaemia, having his hospital chemo at home during lockdown. The treatment is being administered by his CLIC Sargent nurses from the Children's Oncology/Haematology ward at Bristol Children's Hospital. Franck was the first patient of theirs to receive this new way of receiving treatment. The care they give him and us as a family is incredible and we can't thank them enough.

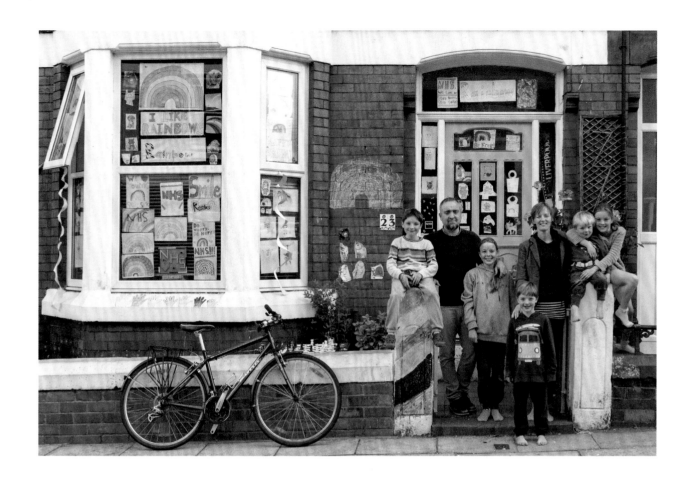

ON YOUR DOORSTEP

BY KENNY GLOVER
LIVERPOOL, MERSEYSIDE

During lockdown, I captured the portraits of over 700 families in Liverpool as a fundraiser for Marie Curie hospices, raising over £10,000 in the process. I feel this image captures so much of the staying at home that many families have done. There's so much going on in the photograph: the chessboard, the bike, the drawings on the windows and walls. So much of it sums up the lockdown for me, from what I have seen of many homes during this period of time. Best of all, though, is that they are all so happy despite everything. It's my favourite of all the portraits of houses I've photographed without a doubt!

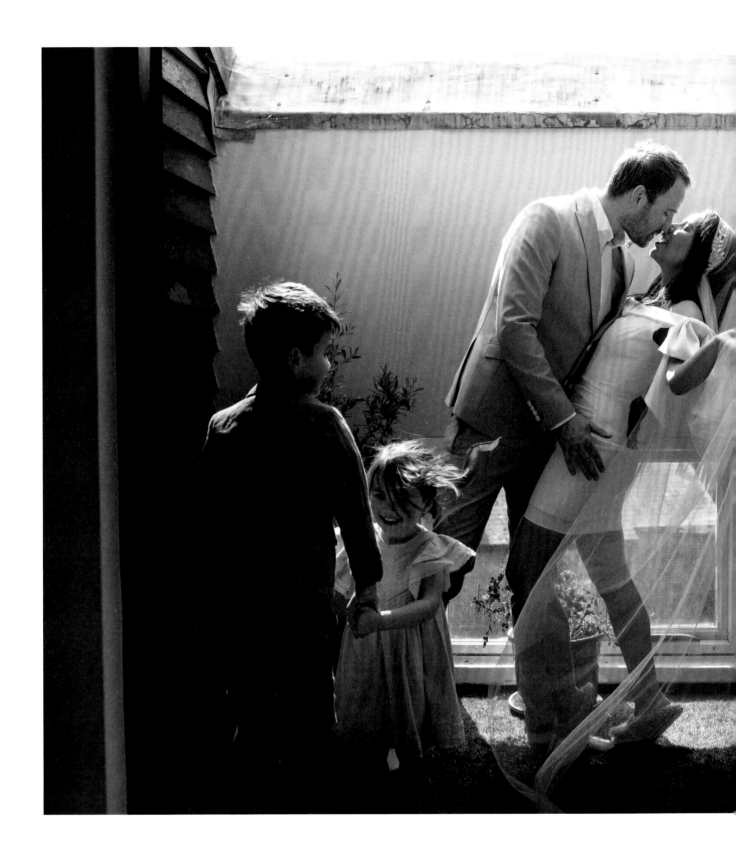

39

LOCKDOWN WEDDING

BY DONNA DUKE LLANDE
BISHOP'S STORTFORD,
HERTFORDSHIRE

We had to cancel our wedding because it was obvious it would have been impossible for it to have gone ahead. It didn't feel right, though, not to enjoy the day when it came around. So we dressed up with our children and celebrated together. It was a fun and memorable day, and it kept a positive spin on what could have been viewed as a depressing situation.

40

AT THE END OF A SHIFT

BY NEIL PALMER
READING, BERKSHIRE

This is a studio portrait of Tendai, a recovery and anaesthetics nurse who was born in Zimbabwe and now lives in my local town, Reading, Berkshire. I wanted to portray her caring side as well as a look of concern and uncertainty that many of us have experienced during this pandemic. It's why I chose a lower than normal angle and asked her to look off camera, placing her halfway down in the frame.

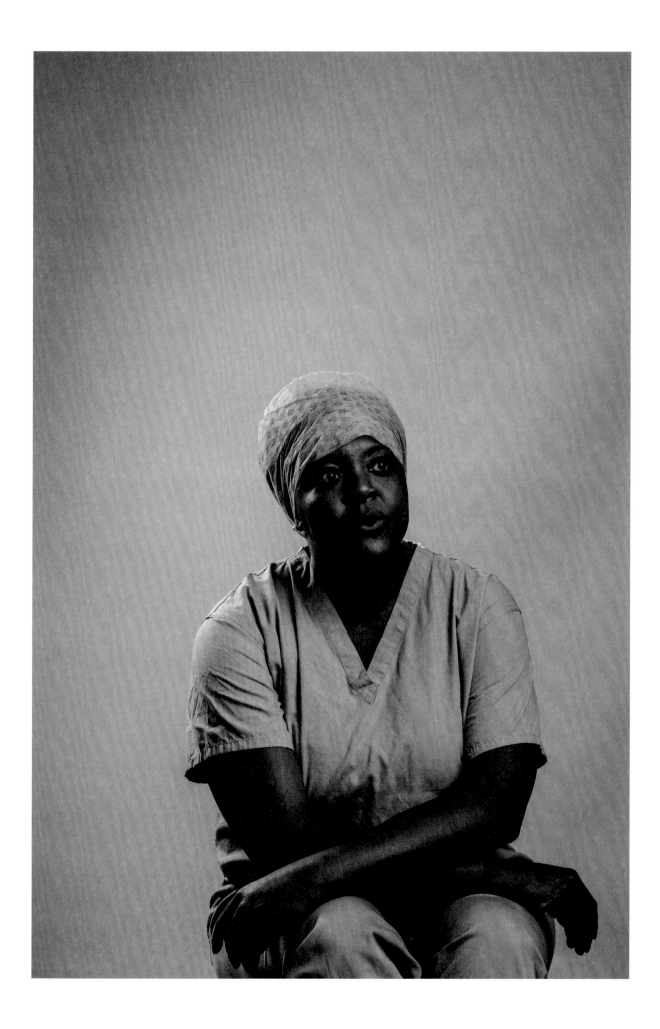

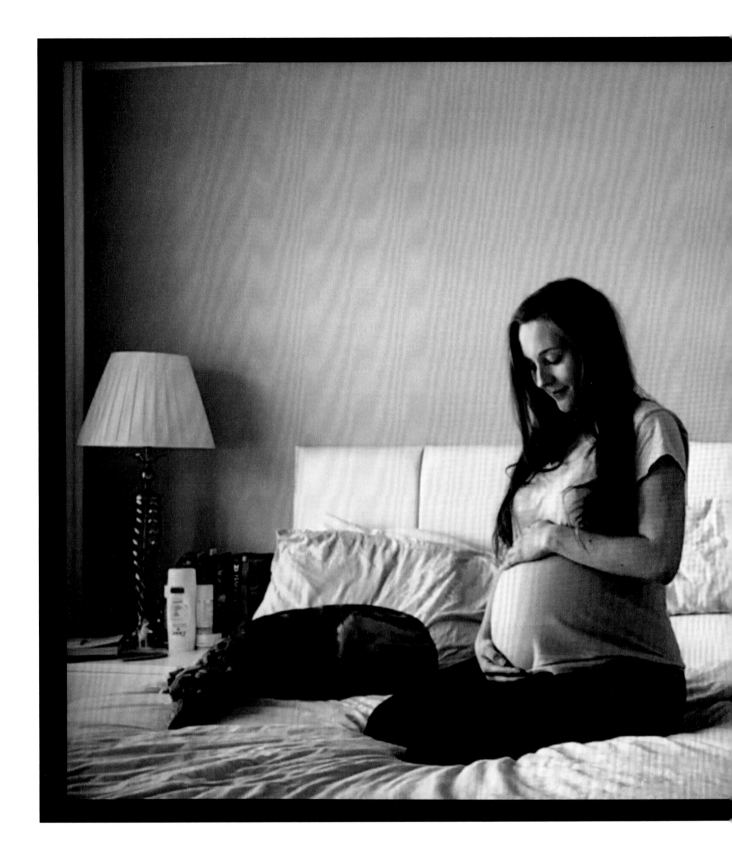

LAURA

BY FRAN MONKS

PLYMOUTH, VIA ZOOM FROM
OXFORD

This is Laura, who I photographed at home in Plymouth, via Zoom from Oxford, as part of a series of portraits of people at home during lockdown. At the time Laura was thirty-nine weeks pregnant with her first child. She had been at home for six weeks, missing seeing her close family and friends in person, and having had to cancel her baby shower. As this was her first pregnancy, she said she didn't really know what it would have felt like if things were normal.

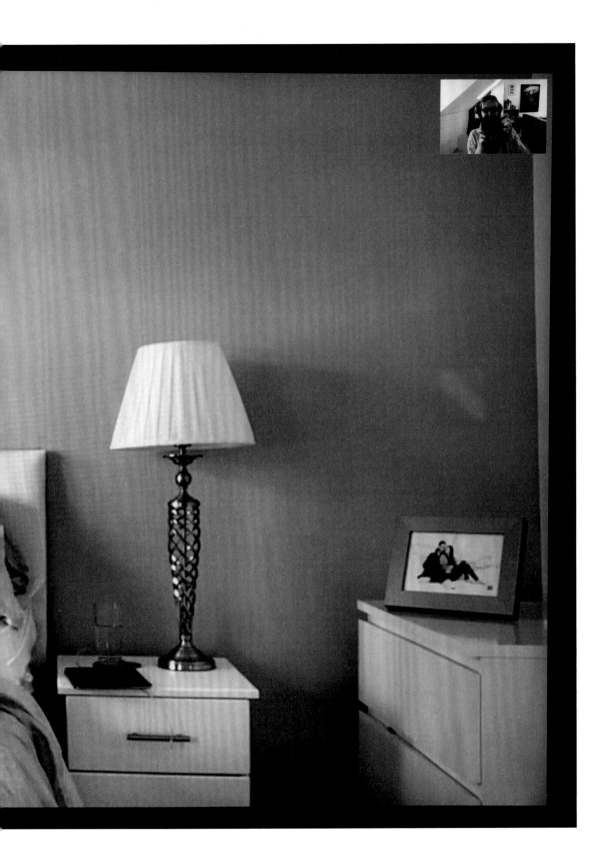

She now has a healthy 3-month-old, but early motherhood has also been shadowed by the pandemic. Photographing people via Zoom is a really collaborative process. Laura, who volunteered to take part in the series via Instagram, showed me around her house before I settled on this composition. I asked her to prop up her phone while she sat on the bed. Bonnie the dog jumped into the frame just at the right moment to help make the picture.

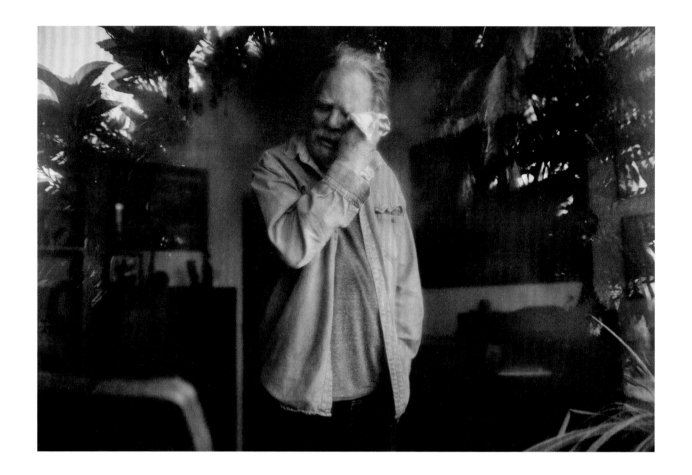

**JUSTIN, FROM THE
OUTSIDE IN**

BY SARA LINCOLN
LONDON

Justin didn't know about my project when I turned up at his window with a camera. I just so happened to be across the road capturing his daughter Safi and her family, who had volunteered to be a part of my 'Outside In' project, which documents my community living life in lockdown through the window. Safi asked if I wouldn't mind popping over to capture a frame or two of her father and I am very grateful that I did. It was wonderful meeting this brilliant man, albeit through the window. We spoke about the project, his art collection and how he manages to keep his plants so well. We talked about how surreal everything is right now, how the weeks have been for him isolating alone and his plans to jet off to France as soon as this madness is over. He finished up by telling me he had a spot of hay fever ... A session that wasn't meant to occur happens to be one of my favourites.

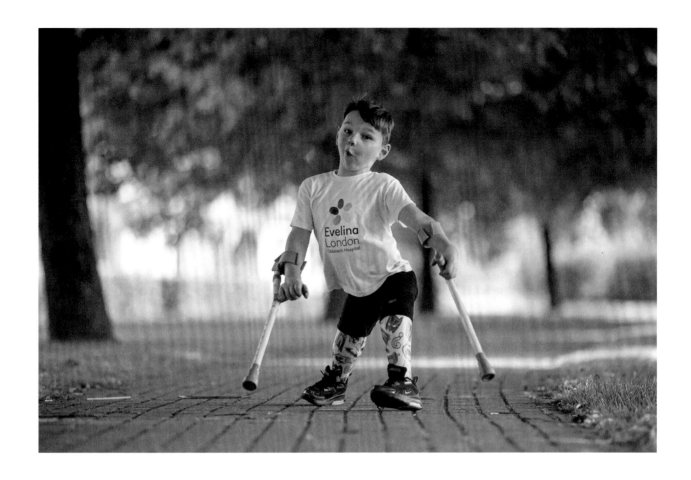

43

**TONY HUDGELL'S 10KM WALK
FOR EVELINA LONDON**

BY DAVID TETT
KENT

This is Tony Hudgell, a 5-year-old patient at Evelina London Children's Hospital. He walked a total of 10km throughout June 2020 on his new prosthetic legs to thank the hospital that saved his life. As a baby, he suffered horrific abuse at the hands of his biological parents; due to extreme injuries, he had to have both his legs amputated and ended up on life support. He had been learning to walk again and, after seeing Captain Sir Tom Moore on the news walking lengths of his garden, Tony said, 'I could do that', and decided to set his own challenge. He set out to raise £500, but raised over £1.2 million for NHS charities. Tony's determination, positivity and strength is inspiring; this was a huge challenge, but he was not phased. I visited him to take photos and couldn't believe the speed he moved at! It was a privilege to meet him. His courage is truly inspiring and he is a great example to anyone who believes in themselves that they can make a difference.

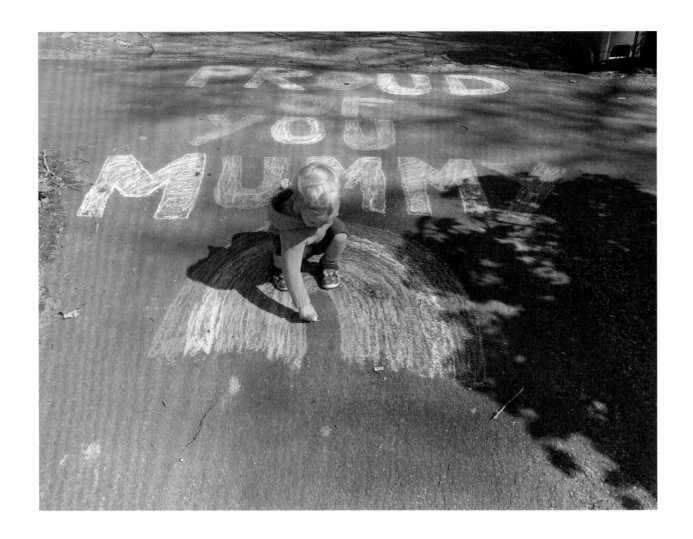

STREET ARTIST AT WORK

BY VICTORIA STOKES
CARSHALTON, LONDON

My triplet sister is a nurse at King's College Hospital, London. She was working on the frontline with COVID-19 patients and had been redeployed to the ICU. She had her shifts and shift patterns changed and as a consequence was spending less time with her son. She was also five months pregnant, but she still went to every shift smiling and not once complaining, even though I knew she was exhausted and sad to not see her son as much. I'm so very proud of her, so my nephew and I decorated the driveway so that she would have something to smile at when she came home from work that evening and know how much we love her.

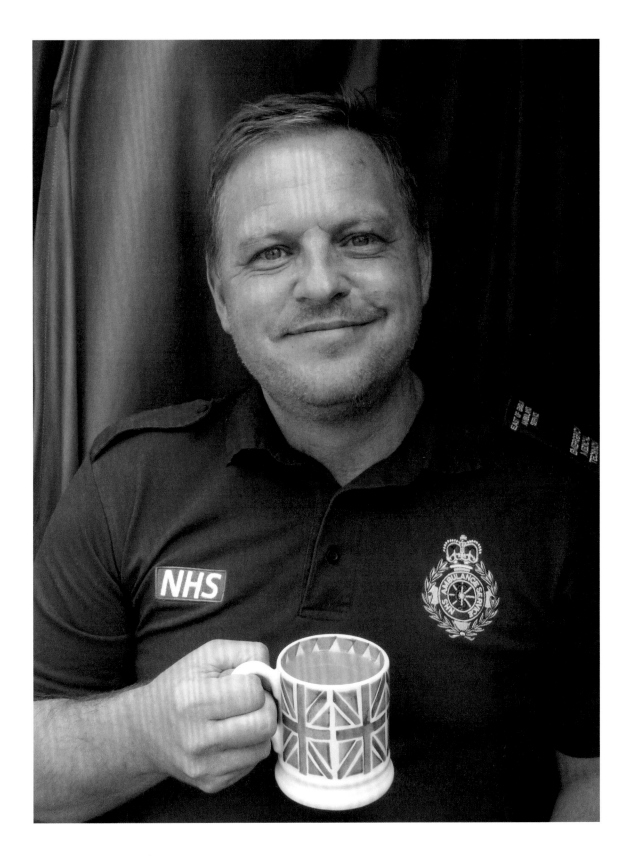

45

**A CUP OF TEA ALWAYS
BRINGS A SMILE**

BY MRS ANNETTE BAKER
WICKFORD, ESSEX

My husband works for the East of England Ambulance Service. We live with my parents during the week while working, but since the start of lockdown we have been unable to do this. Steven is sleeping in our campervan on the driveway whilst on shifts to limit the risk of spreading the virus to the family. Five months on, and he is still sleeping in the campervan after working twelve-hour shifts, to keep my parents safe. There are no words to explain how proud I am of him. A cup of tea will always make him smile.

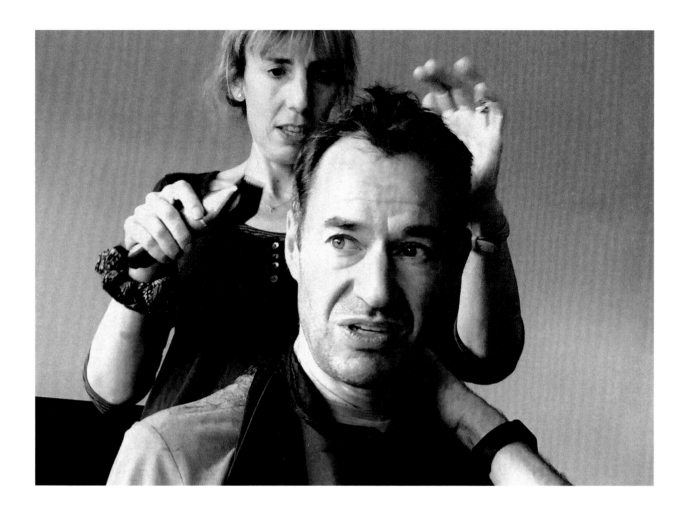

46

SHORT CUT

BY KATE AINGER AND CONI
CHELTENHAM,
GLOUCESTERSHIRE

This image was shot and edited by Coni (aged 4) with my phone, while her dad was having his first lockdown haircut with the dog clippers. We were too absorbed in the tension of the moment to realise she was taking it, so the emotions are very real!

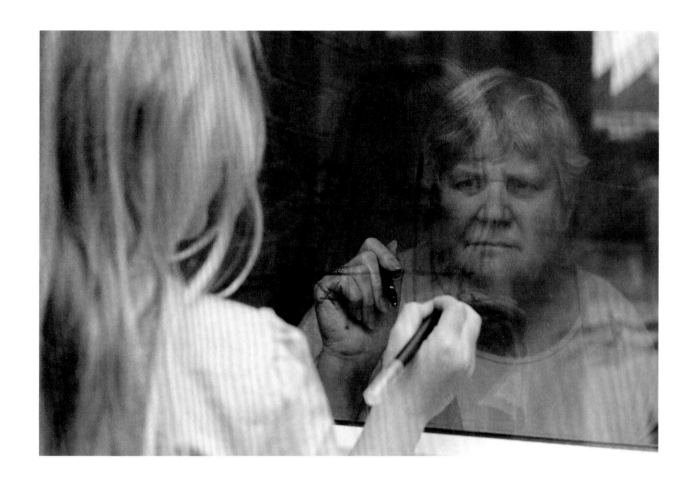

DISTANCED GAMING

BY TRACEY PHILBEY
BRACKLEY,
NORTHAMPTONSHIRE

Lockdown was tough for an only child. While delivering supplies to my daughter Freya's isolating Nana and Pap on Nana's birthday, we raised spirits by playing games through the glass of the front door. Nana looks like she's trying not to be beaten by a 6-year-old! We usually have a big family gathering for my mum's birthday, so this year was very different. I tried to document moments during COVID-19 times by taking photos for Freya to look back on and share with generations to come. We are still unable to give my parents a hug, but we can at least enjoy a drink in the garden with them now. The tense emotions depicted in the image mirror those felt by many during this unprecedented time.

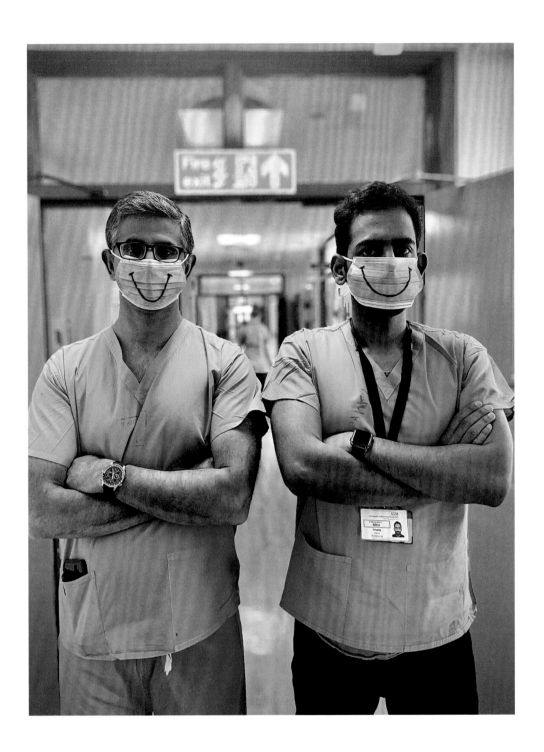

After a long week looking after patients, an orthopaedic consultant and his surgical trainee wanted to lift the mood of not only themselves, but their colleagues and patients on the ward. It's easy to forget how much we need our mouths to communicate and convey emotion, until there is a mask in front to prevent it. I took this picture to show that our NHS and our nation can still find light in the darkest of times. Keep smiling and be haPPE!

I was a final year student doctor at the time and had been drafted in to work for the NHS early. A new type of relationship was formed between senior doctors and students during the pandemic; I was considered 'part of the team'. When I captured this moment, it was a breath of fresh air to experience some light-heartedness during such a difficult time. This photo brings back a mixture of emotions because, a week after it was taken, I contracted COVID-19 myself. Since this was taken, I have graduated as a doctor and worked through a moment in history.

48

haPPE

BY IMOGEN JOHNSTON
LIVERPOOL, MERSEYSIDE

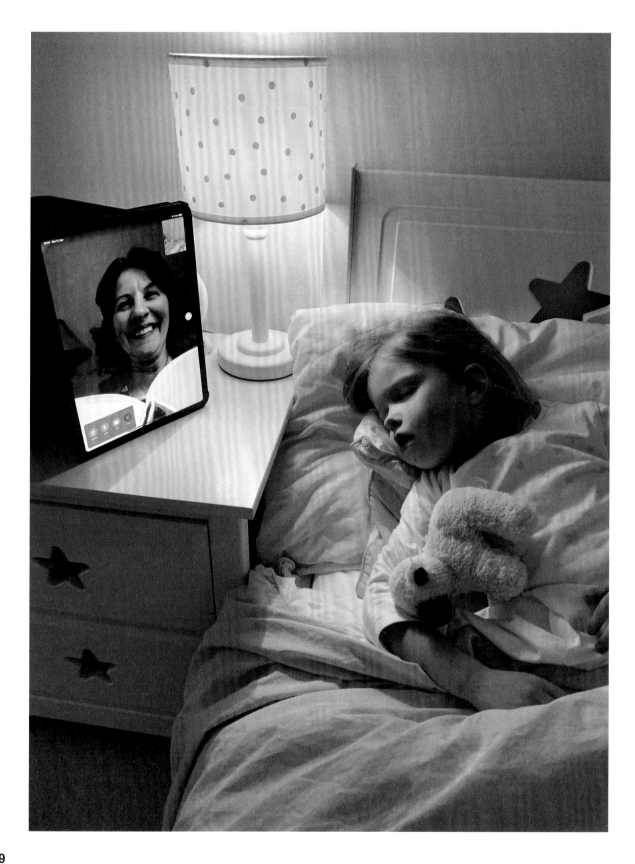

**BEDTIME STORIES WITH
GRANDMA**

BY LAURA MACEY
TONGHAM, SURREY

The hardest thing during lockdown for my 4-year-old daughter Isobel was that she missed being read stories by her grandma, so every few nights her grandma read her a bedtime story via a video call until she drifted off to sleep, dreaming of when they will meet again. They have such a close bond so it was really lovely to see that they could still connect during lockdown, as they missed each other so much.

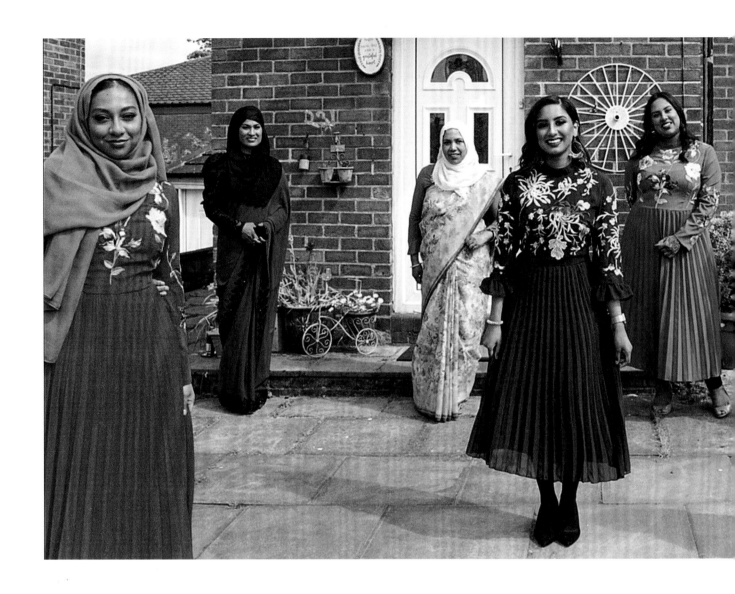

Every year, following the holy month of Ramadan, we are used to celebrating Eid Ul-Fitr, starting the day with congregated prayers at the mosque, enjoying a special Eid breakfast as a family and wearing our best clothes. We then spend the rest of the day visiting the houses of our loved ones, sampling each other's food and taking selfies. However, this Eid was very different; respecting lockdown restrictions meant that there were no prayers at the mosque, no Eid hugs and no time spent with our extended family and friends. Despite the unusual circumstances, as a family we found that we had time to reflect upon our faith and how much we value the health and safety of each other more than anything. We hope that this time next year, we will be able to embrace one another and make new memories, remaining humble from our experience in 2020. This is our socially-distanced family photo from Eid Ul-Fitr 2020.

EID UL-FITR 2020

BY ROSHNI HAQUE
STOKE-ON-TRENT,
STAFFORDSHIRE

THE LOOK OF LOCKDOWN

BY LOTTI SOFIA
LONDON

This is my lockdown pal, Pepter. Lockdown has forced a large majority of us into mandatory stillness. Some may see this as a blessing, and others a curse, because limited activities means limited distractions from our thoughts, worries and ultimately ourselves. This picture is a representation of our daily dose of daydreaming that we do while we watch the world go by without us.

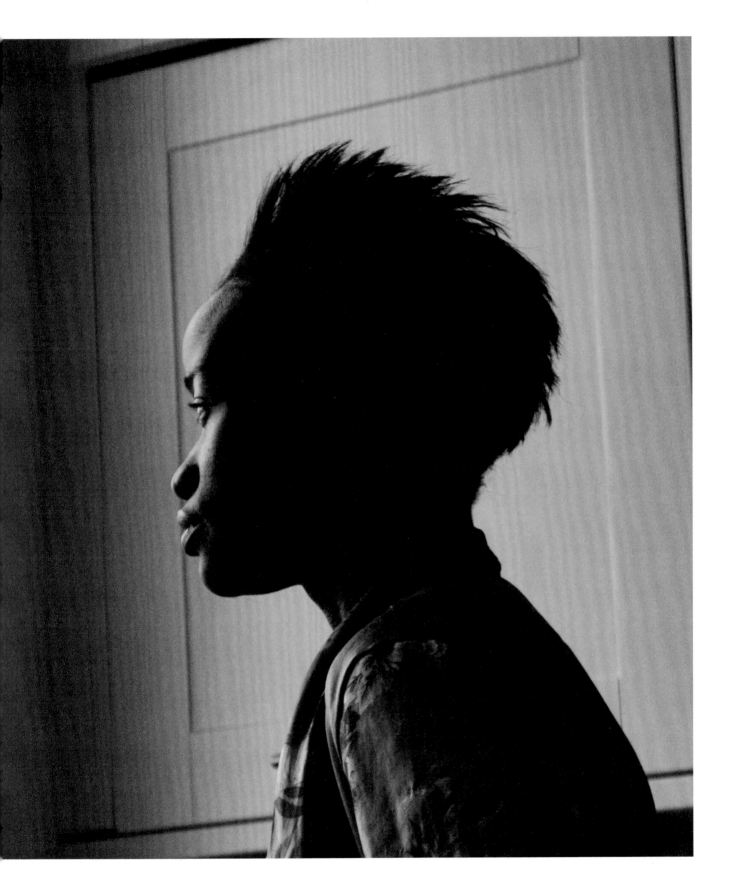

Be kind to yourselves during lockdown and use this stillness to explore
any uncomfortable feelings that may have arisen. We've felt lonely, sad,
worried, confused, anxious and everything in between, but we are grateful
for every key worker, our health, and for the humanity and empathy that has
grown out of this dreary time.

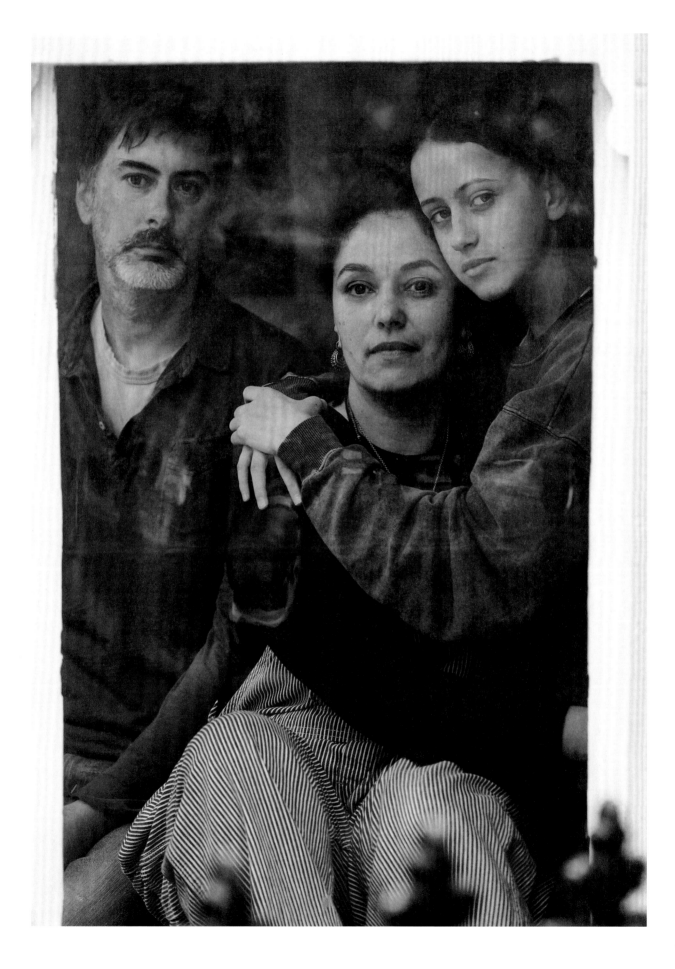

**RUTH, DAVID AND SCARLET
IN LOCKDOWN**

BY SARAH WEAL
LEWES, EAST SUSSEX

This image was taken as part of a series of lockdown portraits called 'Furloughed Friendship'. It explored the loss of connection I felt with the friends in my home town of Lewes during the UK lockdown. In this portrait the quiet tenderness of Ruth, David and Scarlet and their support for one another was something I found very moving to photograph. I took all the portraits in the series during my daily walk. The glass between us, protection from illness, distance imposed and, on occasion, a mirror of the world that we looked out onto, but were often denied. Not being able to communicate with my subjects easily, made for a less collaborative way of working than I am used to. The feeling of solitude and separation from my friends was often intensified by this way of working. As with the lockdown period in general, a period which highlighted losses and gains in society, the very act of photographing my friends in this way was bittersweet.

53

JOANNA IN PPE

BY HARRY HALL
CAMBRIDGE

'Babies aren't going to stop being born for a pandemic!' Joanna is an NHS midwife at the Rosie Hospital in Cambridge. I'm intrigued by how PPE has changed the process of welcoming a newborn child into the world. It has forced new barriers between midwife and mother that previously didn't exist. A huge part of Joanna's job involves giving clear communication and comfort, which is vital for effective care. Not only has PPE created difficult working environments for staff, it has also left mothers feeling distant and scared during an unnerving time to give birth. I love how Joanna's name is written on her visor which is a way her hospital has tried to instil familiarity. Her eyes remain so warm and welcoming. I wanted to make this portrait as a visual reminder of this unique moment in Joanna's career.

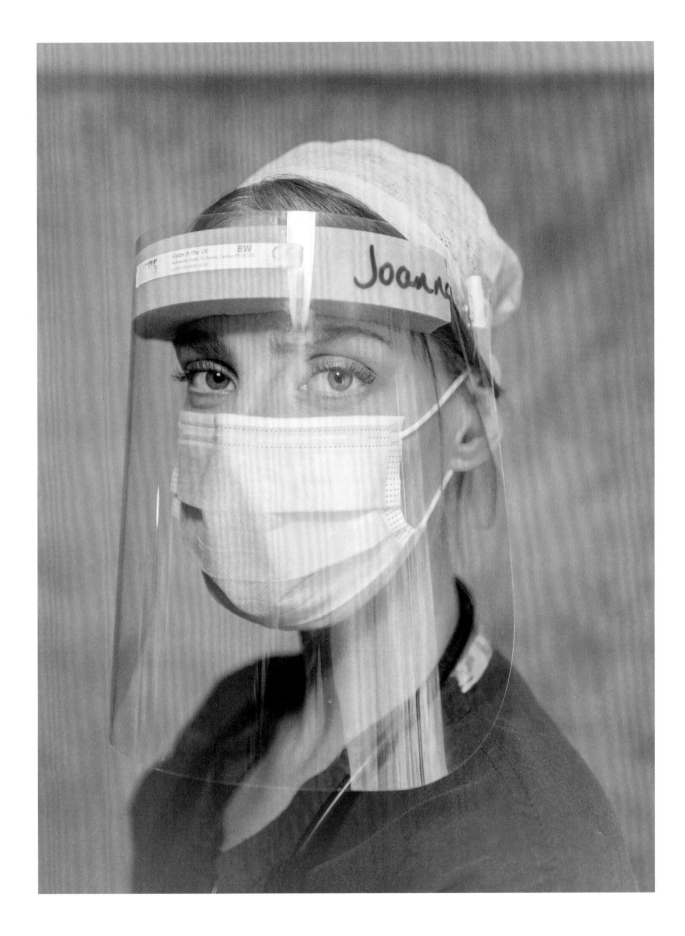

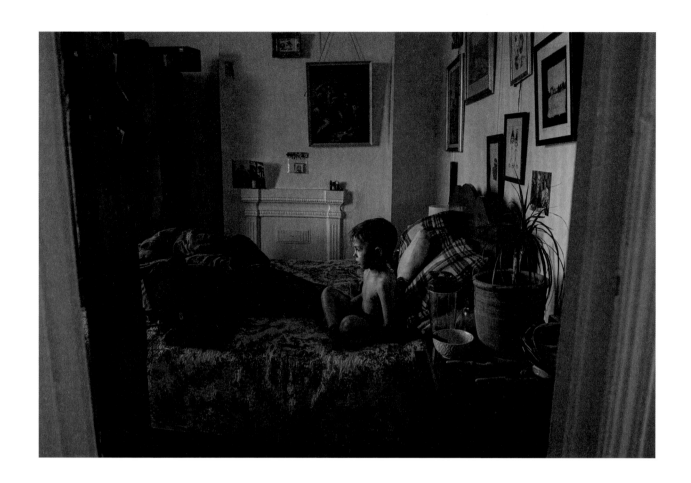

MY ONLY FRIEND

BY RAH PETHERBRIDGE
CROYDON, LONDON

Myself and my husband lost our jobs just before lockdown as we work in the theatre industry. We're so frightened about the future of our trades and it's a little overwhelming to try and predict our own futures. This photo was taken on a day when I was feeling particularly down and lonely. I set my son Phoenix up on my bed with blankets, a movie and a snack and went to have a good cry in the bathroom. When I came back he was sat there engrossed, content, safe and completely oblivious to any struggle we could be experiencing. Perfect peace. I joined him shortly after this and attempted to soak up the serenity of that moment.

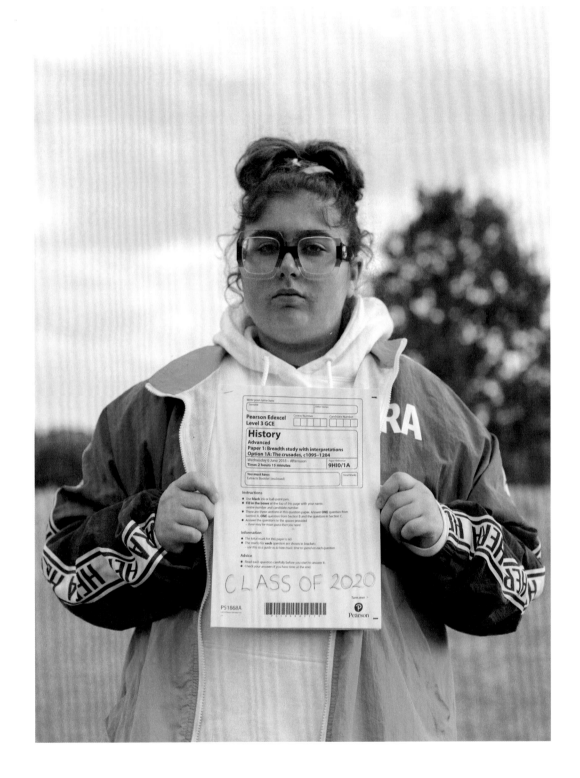

55

CANCELLED

BY NIAZ MALEKNIA
PRIMROSE HILL, LONDON

To be told that your A-level exams have been cancelled may seem like a dream come true. However, in reality, it's far from the truth. The class of 2020 have experienced disappointment at so many levels. Exams, graduations and proms cancelled, not knowing how their university life will look. During lockdown I feel that there was not enough said about the disappointments that many of these students have had to face due to coronavirus. In my opinion, they are the Silent Heroes. They will be the ones facing the 'New Normal' as they step into their chosen paths after leaving school. I feel they went unnoticed in the main during this difficult time. However, they have also been one of the most affected and most patient groups.

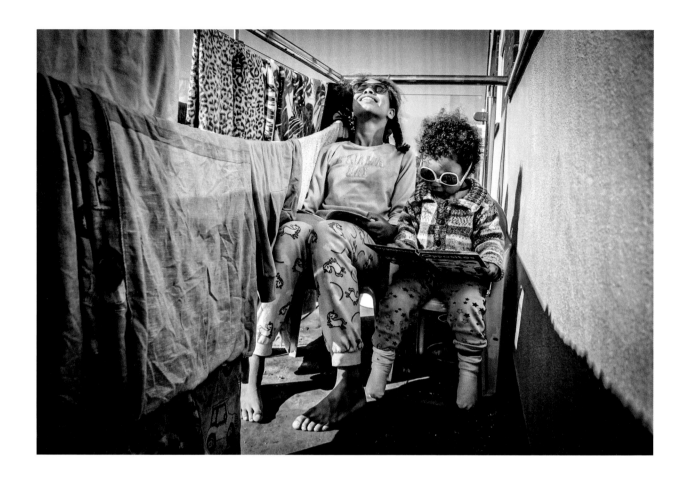

OUTDOOR SPACE

BY VAL AZISI
LEE-ON-THE-SOLENT,
HAMPSHIRE

This photograph was taken in a single-parent household with three children living in a second-floor flat. We have spent many of our days on here appreciating this small, confined outdoor space.

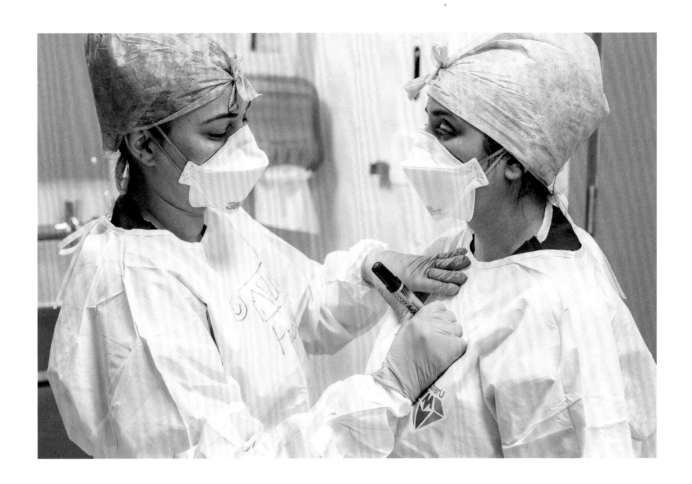

ALL IN THIS TOGETHER

BY JOYCE DUAH
LONDON

I'm Joyce, a specialist oncology pharmacist at St Bart's hospital. My portrait is of Amelia and Dipal, two of my many colleagues who have been drafted-in to work on our Intensive Care Unit. They have been working hard as pharmacy technicians, delivering vital medication multiple times a day to ITU. I've watched Amelia and Dipal with such admiration for what they are doing and more importantly their positive attitudes. They spend their precious lunch breaks encouraging each other with humour and I think they are so brave. I decided I wanted to use my photography skills to document some of their journey. I asked Amelia if she would mind if I took some pictures of them donning their PPE and she happily accepted. I'm so proud of the team and all they do and it's been a privilege to capture their journey during this historic time. One of their practices is to write their names on their gowns so that colleagues are able to recognise each other under their PPE and to help the patients who are conscious to feel closer to their carers.

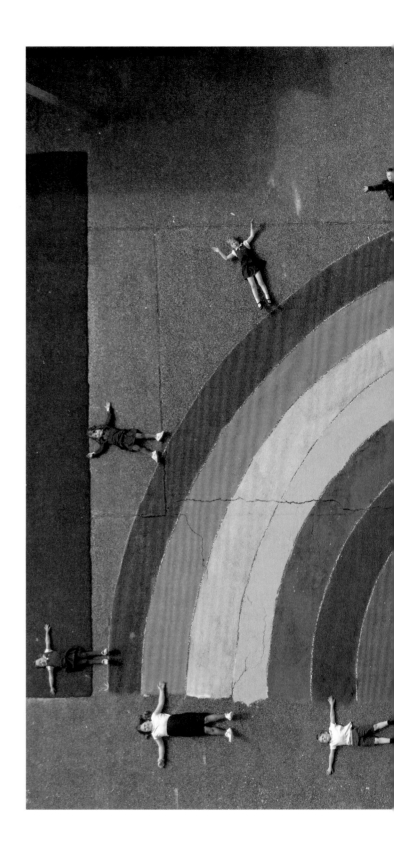

OVER THE RAINBOW

BY CHRIS TAYLOR
SHERINGHAM, NORFOLK

The children of key workers at Sheringham Primary School, Norfolk, created this huge rainbow for the NHS on their playground. Some of the children's parents are nurses who have been working on the Covid ward at the Norfolk & Norwich University Hospital.

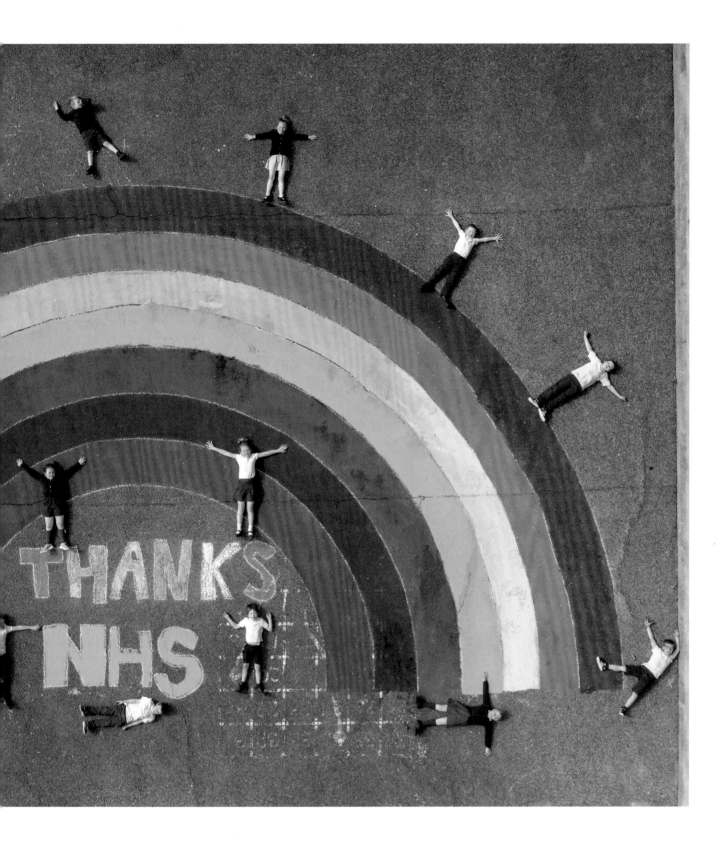

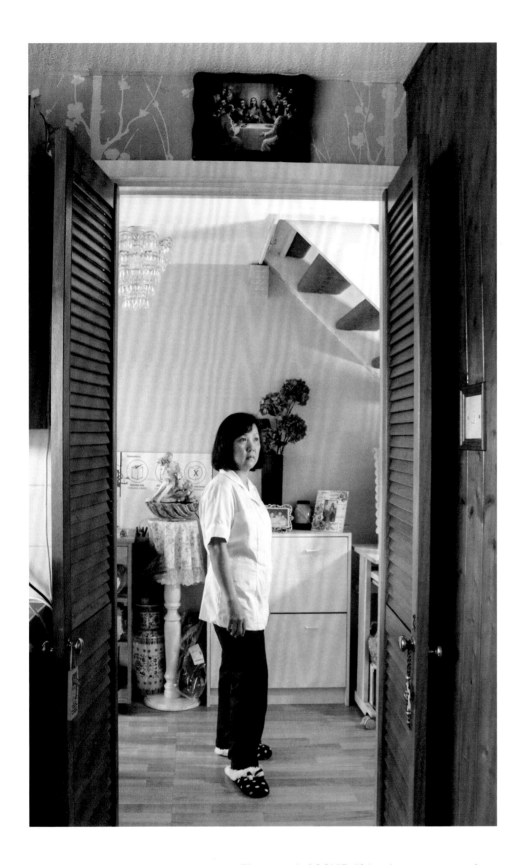

59

ILAW NG TAHANAN

BY ROMINA AMOR RABE
EASTBOURNE, EAST SUSSEX

The spread of COVID-19 has been a source of stress and concern in my family, as my parents continue their work for the NHS. I started this project to document my family's life during the pandemic. Like many other immigrants, my parents moved to the UK in search of a better life for their children. The title 'Ilaw ng Tahanan' translates as 'the light of the home', which describes the role of mothers in Filipino culture, as they are seen as bringing warmth and hope to the home.

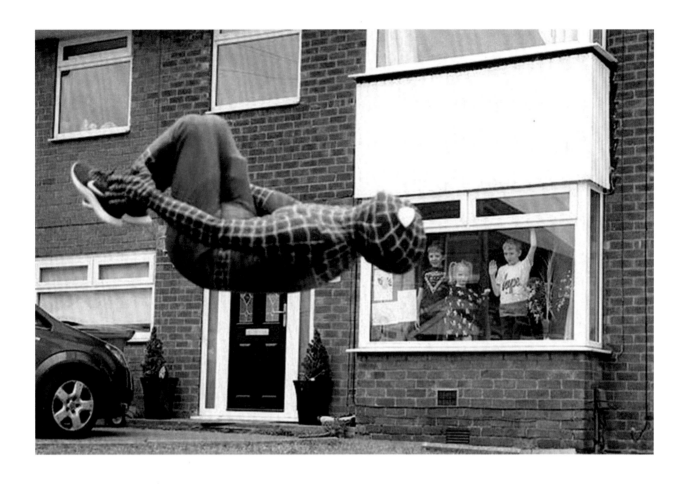

60

**STOCKPORT SPIDER-MEN
BRINGING SMILES TO
CHILDREN IN LOCKDOWN**

BY JASON BAIRD
STOCKPORT

The Stockport Spider-Men was started by friends Jason Baird and Andrew Baldock, who both took to the streets of Stockport right at the start of lockdown dressed as Spider-Man to use their daily exercise time to keep the children smiling. This then turned in to a national phenomenon, with over fifty other members of the general public joining dressed as various other characters. On top of visiting the community to bring 'social distancing smiles', as Jason called it, Jason also set up a JustGiving fund for the NHS Charities Together, and in the four months of lockdown raised over £60,000 for the real superheroes, our wonderful NHS.

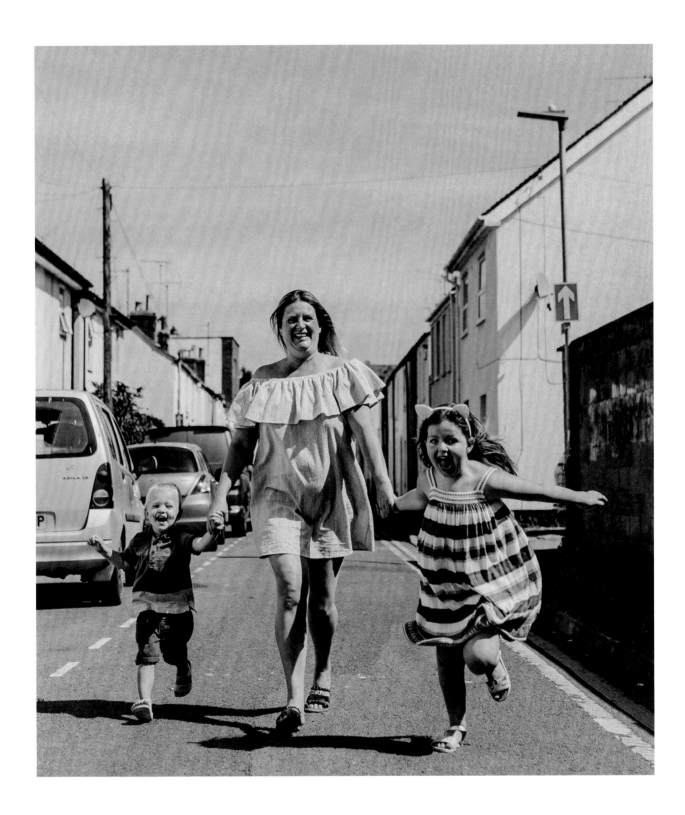

61

BIRTHDAY LOCKDOWN

**BY KATE SARGENT AND
RACHEL SCARFE**
CHELTENHAM,
GLOUCESTERSHIRE

This was a hard day, as I was not able to see my family and it was my first time out due to shielding because of bowel disease. We had been in since March (my children were taken out by their dad), but what an amazing day I had. This picture, taken by my talented friend Kate, captured my birthday with my amazing children ... Thank you for choosing me to be a finalist, I actually can't believe it.

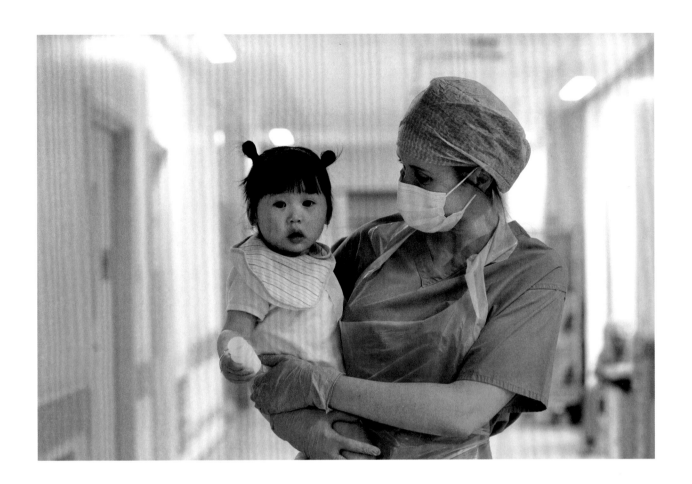

YOU'RE IN SAFE HANDS

BY LISA MILLER
GLASGOW

This photograph shows Hanna and her nurse heading to theatre for a procedure during the COVID-19 pandemic. During this uncertain time, I felt it was important to document this shared experience and capture a moment that highlights care, compassion and positivity.

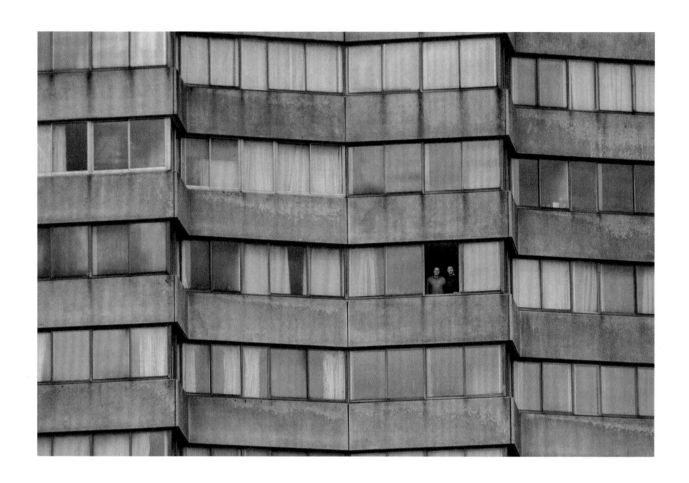

This photo forms part of a series I captured entitled 'Lockdown Life', honestly documenting life in lockdown in 2020. A moment in time which saw everyone united in staying at home, holding still. So many moments in life are still happening in these places we call home and this project looked to explore and capture this.

Shoots were no more than five minutes and captured at a social distance. This image in particular has always felt iconic to me. I adore the architecture of Arlington House in Margate, and for me it really symbolised the solitude and stillness of lockdown in Thanet, East Kent. This image was a logistically interesting one to create, taken from over 200m away, texting Paul and Simon to come to the window of their fifteenth floor home. I often think about how we gaze upon a photo and the narrative it sparks in our minds. Most of all here, I think about what the perspective must have been like for Paul and Simon, looking out across an empty beach and quiet roads in Margate.

63

**LOCKDOWN LIFE –
PAUL & SIMON**

BY REBECCA DOUGLAS
MARGATE, KENT

HOLDING TIGHT

**BY KATY RUDD AND
JOE WYER**
REDHILL, SURREY

This photograph was taken on the commemorations of VE Day, 8 May 2020, a beautiful sunny day. During lockdown, we couldn't see our family or friends, and Katy's freelance work in the theatre had disappeared over night. Our three square metre front garden had become our haven as we spent hours playing with our son Wilf and reading stories. On VE Day, we hung up Wilf's great grandfather's Second World War flag in our small patch and had a picnic – our neighbours did the same. Lockdown was hard, but it brought our community together and it gave us time together as a family. We were feeling grateful for that.

65

ONE TEAM

**BY MATT UTTON AND
JENNIFER O'SULLIVAN**
HAINAULT, LONDON

This is a photo of Jen and her little girl, Florence. Jen worked through the pandemic, and Florence loves dressing up like her mum. Jen has described this photo as being one of her most treasured items as it represents a lovely moment in what was a pretty tough time emotionally and mentally. It's clear from this photo how much they love each other, and really are one team. The photo was taken as part of a socially distanced lockdown photography project. I offered photos of families, as a way of remembering what lockdown represented to them. As a part of this project, donations were made to the Cavell Nurses Trust, which is a charity that helps nurses, midwives and healthcare workers in times of need.

66

ISOLATED TOGETHER

BY DR BEN TIMMIS
EMSWORTH, HAMPSHIRE

I'm self-isolating with my wife, and took this picture of us using a remote control. When lockdown was announced, we realised that we could be facing many months in constant company with each other, something we had never done before. We decided to make the most of it, and if the COVID-19 pandemic has had any silver lining for us, it is the realisation of our enduring love for each other. I hooked a piece of old black velvet on the wall, set the camera to take a picture, and that was that.

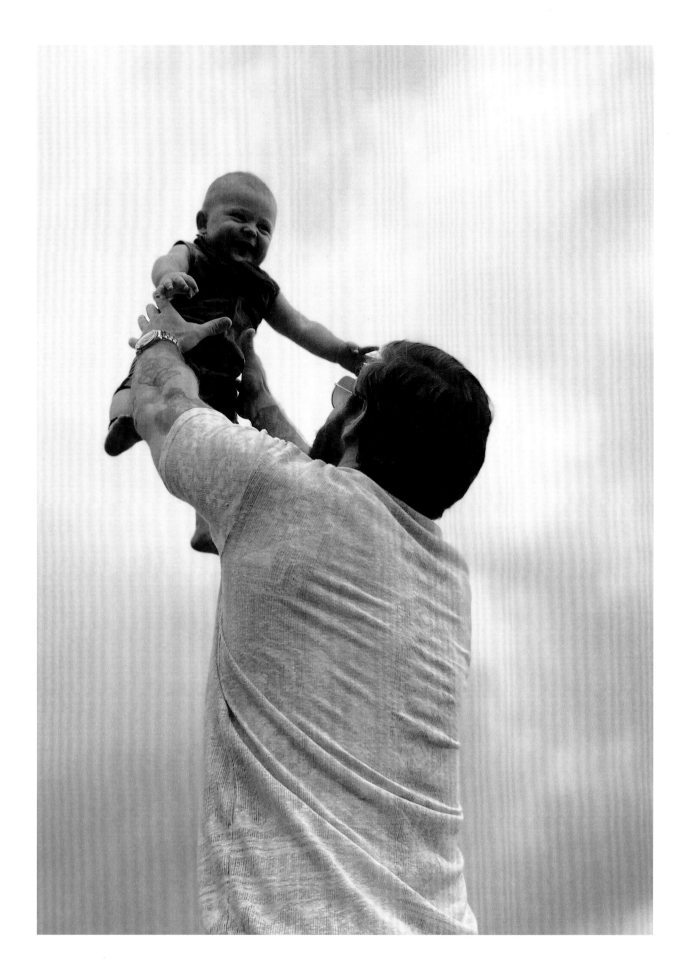

67

OUR HERO'S SURPRISE RETURN!

BY JENNI NORFOLK
TITCHFIELD, HAMPSHIRE

Rory's Daddy is a submariner for the Royal Navy and was sent away at the beginning of lockdown in March to quarantine on the submarine. Having been just Rory and Mummy for three months, we were worried about the impact lockdown would have on his socialising, and, more importantly, would he remember Daddy? I think this image gives us the answer we were hoping for!

Looking at this photograph fills me with emotion. Proud of my husband who works so hard in defence of our country, happiness that the energy and time I put into raising my son alone despite this pandemic is producing a happy well-rounded child, and total joy in the face of the beautiful child that we made together seeing his hero for the first time in so long. Life may have felt like it stopped for many, but for our children every day is new and exciting, and the arms of their parents will always be the safest place on earth.

I-SPY

BY RORY TRAPPE
BLAENAU FFESTINIOG,
GWYNEDD

We could hear our grandson playing on the patio when I shouted up saying that we (both grandparents) were passing by. He ran over to a gap in the patio glass to have a look and see if he could spot us. We laughed when we could see that he had muddy hands as he had been playing in the soil, which had just been put down for some newly planted bushes. I joked with my wife saying that he looked like a convict trying to escape from prison!

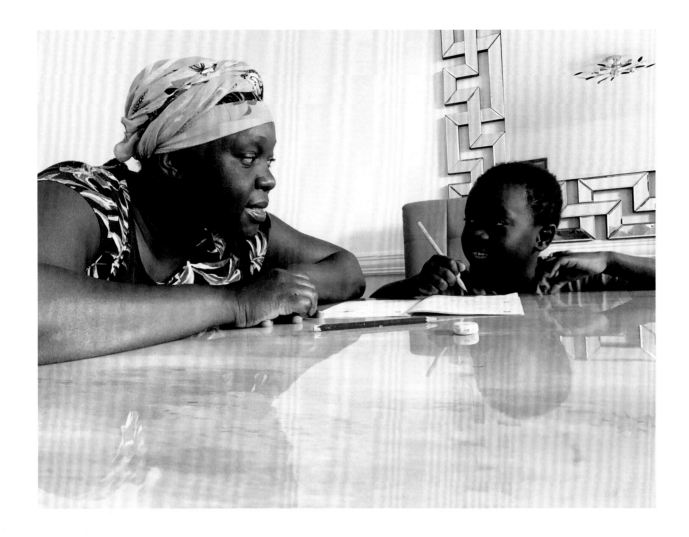

SCHOOL

**BY MARCELA
(AGED 17 YEARS)**
DAGENHAM, LONDON

During lockdown, my mum had to become a primary school teacher for my brother. This moment captures one of the few times my brother was eager to do his homework. Through this photograph, I wanted to convey a warm feeling of when a family is together.

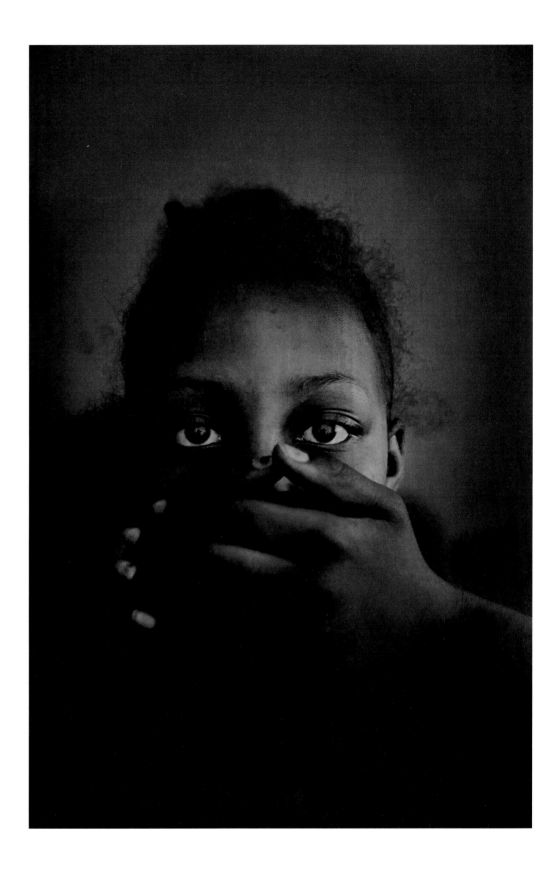

70

I CAN'T BREATHE

BY PAPAJGUN (JAMAL YUSSUFF-ADELAKUN)
EDINBURGH

My daughter and I have bonded and created previously when it comes to photography, but never before have we both used the medium of photography to talk about racial injustice or racism. For me, this was a new way to have that conversation with her.

JOE AND DUKE BROOKS, LOCKED DOWN, A FEW DAYS BEFORE THEIR 18TH BIRTHDAY

BY SARAH LEE
LONDON

This was taken as I was visiting Joe and Duke's mother to collect the hand-made masks she'd made for me and my husband (who I am shielding due to his being particularly vulnerable to the virus). They are identical twins and the sons of one of my dearest friends – I've known them since they were very young. Duke has assisted me on shoots and wants to work in the music industry, film or photography. Joe has always wanted to be a make-up artist and hairdresser (he already assists on large shoots and works in a salon).

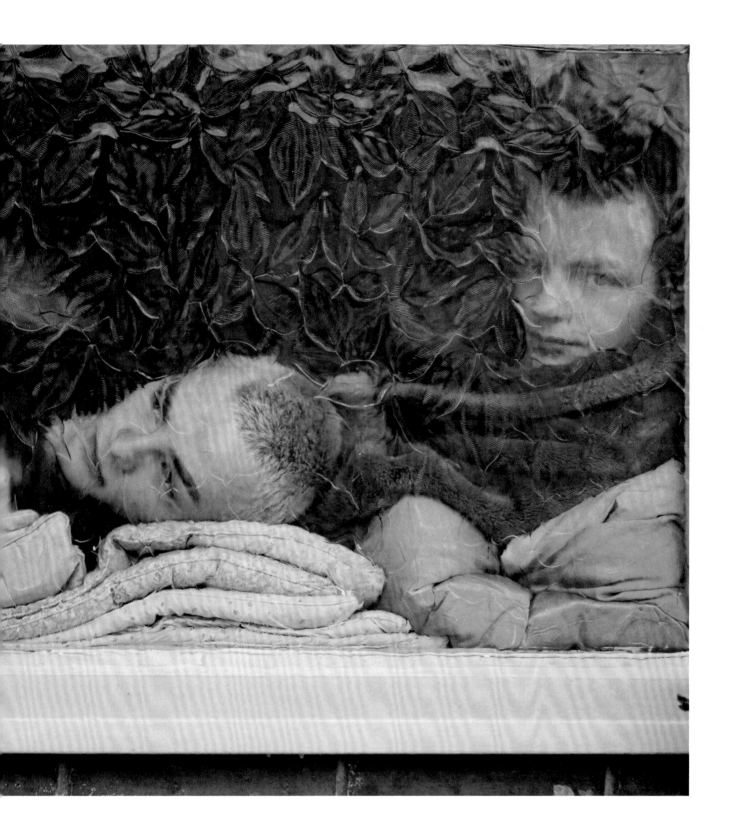

I'm incredibly proud to call them my friends too. Those visits, at first
through a window, and now masked and cautious sitting on their balcony,
have been a godsend during this isolated period. It's always a joy to see them.
Yet here I could feel the ennui and frustration of two young men who suddenly
found themselves entirely housebound and trapped just as their lives were
about to open up in the most exciting of ways with their 18th birthdays and
their first adult summer.

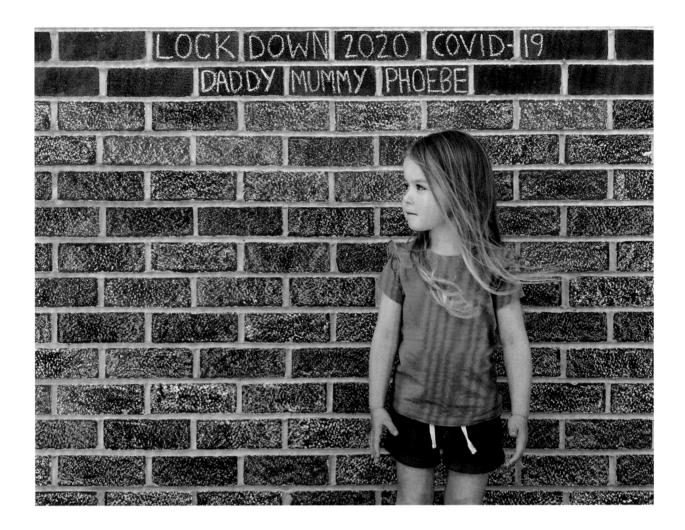

**LOCKDOWN 2020
RAINBOW WALL**

BY RACHEL LOUISE PUGH
KNYPERSLEY,
STAFFORDSHIRE
MOORLANDS

During the COVID-19 lockdown I wanted to make some inspiring memories of such an unprecedented time with my 3-year-old daughter, Phoebe. I wanted her to remember this unusual time in a positive light. It was very worrying and disconcerting for me and many others as this was all unknown territory, though I would like to think that Phoebe will always remember the special time we had together at home. We drew rainbows to display in our window to thank all of the NHS and key workers. Phoebe is also known as 'a rainbow baby': one who was born to family after the loss of a child through stillbirth, miscarriage or death during infancy. The rainbow is a symbol of the hope brought by the child after the storm of the previous loss. We made a family picture of our painted handprints and we also coloured in a section of our house in rainbow coloured chalks.

I wanted to do something to mark this historic period so that Phoebe would be able to look back on it in years to come and maybe even one day show her own children the photos and drawings. Photographs are so important and often a photo or a drawing can help to trigger a buried memory or recall a precise moment in time much more rapidly than words.

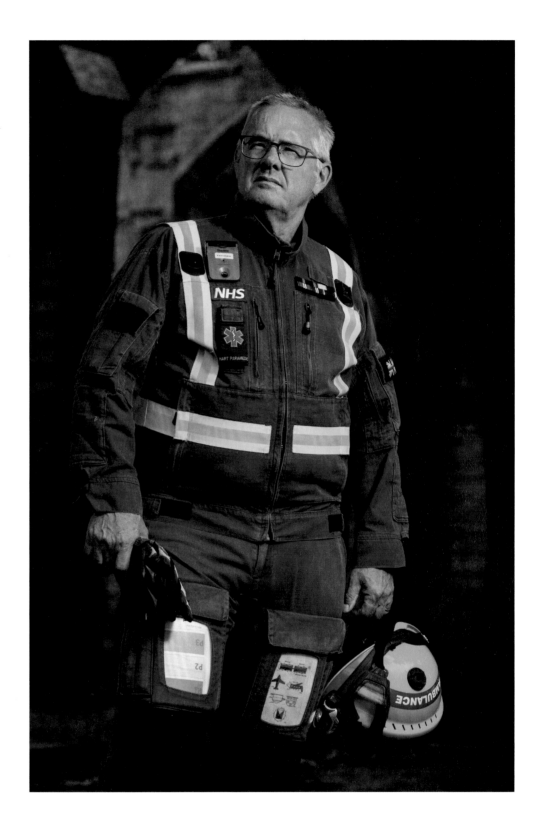

**FROM ONE FRONTLINE
TO ANOTHER ...**

BY STEVE JENKINS
STONEHOUSE,
GLOUCESTERSHIRE

Former soldier and Hazardous Area Response Team (HART) paramedic Dave Thorpe is just one of the extraordinary people in the fight against coronavirus. The HART paramedics work alongside the other emergency services at the centre of serious incidents or threats to public health, and provide care to any people within a hazardous environment who would otherwise be beyond the reach of NHS care. I wanted to portray him in a 'heroic' light, his expression is one of determination and stoicism. Just like his fellow NHS colleagues and key workers, not thinking about himself, but the care and needs of those less fortunate.

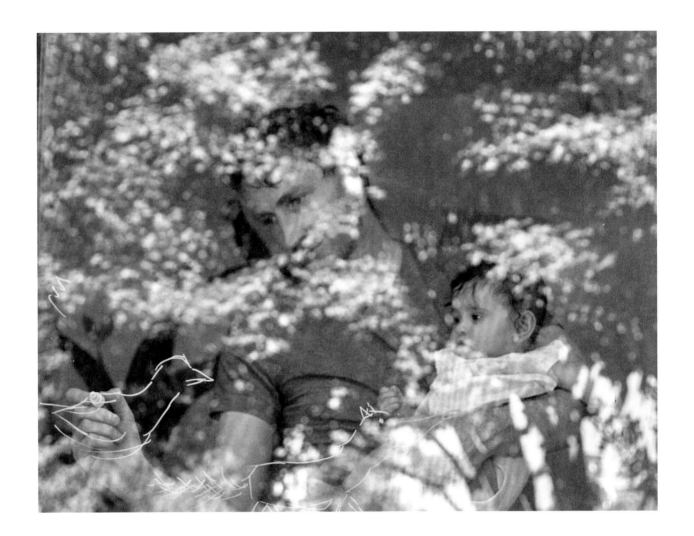

NEIL & SIENNA

BY LISA BENNETT
LEYTONSTONE, LONDON

As part of a personal project, I asked people to draw or write something on their windows on the theme of lockdown. Neil is drawing things he can see from their windows for his 6-month-old daughter, Sienna. They hadn't left the house in weeks so the sight of the trees, birds and foxes in their back garden were the only view they had of the outside world. Neil and Sarah are such a creative couple, so I thought of them first for this idea. They are good friends who live nearby so it was lovely to spend some time catching up and doing something fun during lockdown.

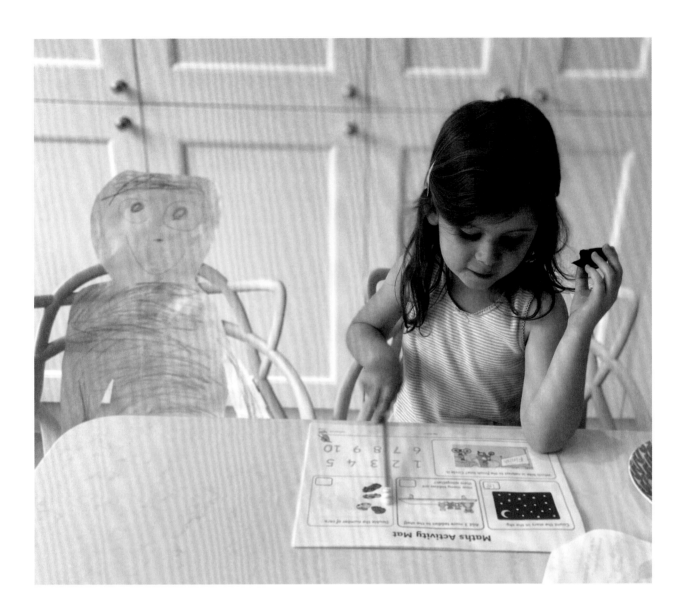

**NEVER WITHOUT
HER GRANDMA**

BY MELANIE LOWIS
TEDDINGTON, LONDON

Millie (5 years old) made a cut out of her much loved grandma (73 years old). Millie sees Grandma almost daily and lockdown prevented the pair from seeing each other. As a retired teacher, Grandma would have made the perfect partner to help Millie with home-schooling. The bond between this grandma and granddaughter is truly a special one and when lockdown ends, and the real grandma can return, it will be a very happy and emotional reunion.

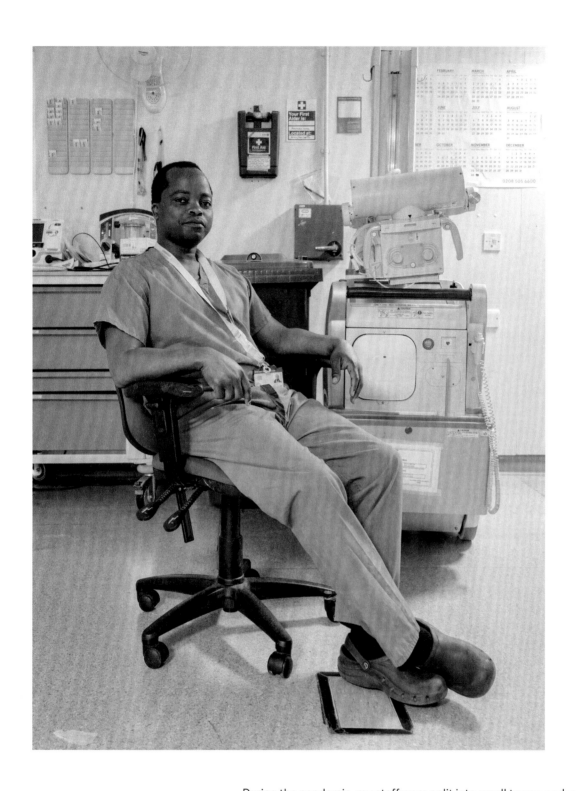

END OF A NIGHT SHIFT

BY KYLE DAVID TALLETT FRPS
ASHFORD, KENT

During the pandemic, my staff were split into small teams and we worked twelve-hour alternate day and night shifts. Early on, I wanted to record my team in action, something to give them at the end to remember our experiences by. I did this and it was popular. On this day, I was leading the day team. I walked in to take handover from the night team that Allen was leading. I sat opposite him and I thought, 'There's a picture: a determined healthcare worker at the end of a trying shift.' My staff come from all over the world, we are a real international unit. As such we are a great team, really tight and we got tighter as the pandemic progressed. I never saw panic at work by anyone – no matter how bad things were, I only saw a calm professionalism. I think this picture captures this. It reminds me of good colleagues and I cannot put into words the feelings towards my team; I don't need words, this image says it all.

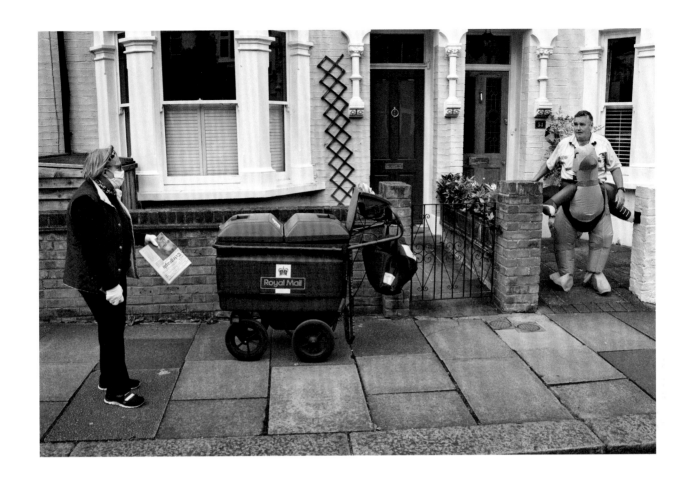

EVERYDAY HERO

BY ARNHEL DE SERRA
LONDON

When I drove past Richard I had to do a double-take, as I couldn't believe he was out on his postman's round in fancy dress. I asked if I could photograph him, and over a few days we got to know each other. Given the doomsday scenario that the media were portraying in the early days of the COVID-19 pandemic, I felt very strongly that here was a man who had something deeply personal and positive to offer his community. Is it an earth shattering news story? Probably not. As a human interest story, however, I feel that his generosity of spirit should be celebrated, and I am delighted that he will be part of this very important project.

78

**WITHOUT HELP,
WITHOUT HOPE**

BY LISA LAWLEY
POOLE, DORSET

A raw picture of the hopelessness and desperation I feel during this lockdown, as a shielded person with leukaemia. COVID-19 has taken far more from me than leukaemia has. Stuck on statutory sick pay, facing losing everything I worked hard for, gets too much sometimes. I was training to be a pharmacy dispenser before the lockdown began and had taken less than a week's sick leave from work during and after my diagnosis. Then COVID-19 struck, and having to shield cost me everything I worked hard for. I know this is not a positive photograph, but it is the reality for many people in my situation. It is my new normal and I felt compelled to photograph myself in that moment, perhaps so that someone would see me.

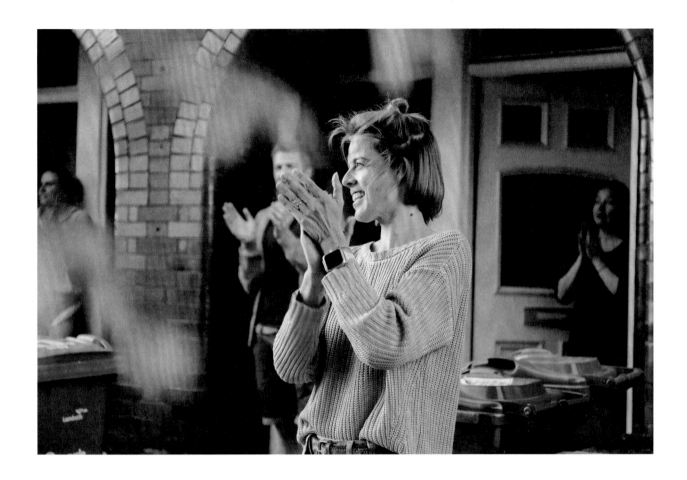

**ANNEMARIE PLAS, FOUNDER
OF CLAP FOR OUR CARERS,
AT THE LAST CLAP**

BY AMANDA SUMMONS
LONDON

Annemarie Plas is both the founder of Clap for our Carers and a Dutch yoga teacher living in south London. Inspired by a similar initiative in her homeland, she instigated the weekly clap on a Thursday night at 8pm. It was to show appreciation for NHS workers and carers fighting the pandemic on the frontline. The clap occurred for ten weeks and Annemarie was the proud face of the initiative. This photo was taken on the final official clap. Annemarie had mixed feelings about ending the clap but wanted it to go out on a high note before becoming politicised further. She told me her favourite part about the initiative was personally getting to know her neighbours, like many of us across the country. I photographed her as part of my charity doorstep photography series, #SWLondonStaysHome. Her doorstep just happened to be simultaneously broadcast across the nation on the BBC! Annemarie had a simple idea that took hold in the national consciousness during lockdown to show our appreciation for those risking their lives.

**WAVING TO THE
OUTSIDE WORLD**

**BY PRIMROSE
(AGED 12 YEARS)**
SOUTH BRENT, DEVON

One of the highlights of my lockdown home-school was taking part in Photo S'cool with other kids. It was so much fun having the time to get creative at home, learn how to use a camera and take pictures of my family. This is a selfie and I received a highly commended for it. I love taking photos now.

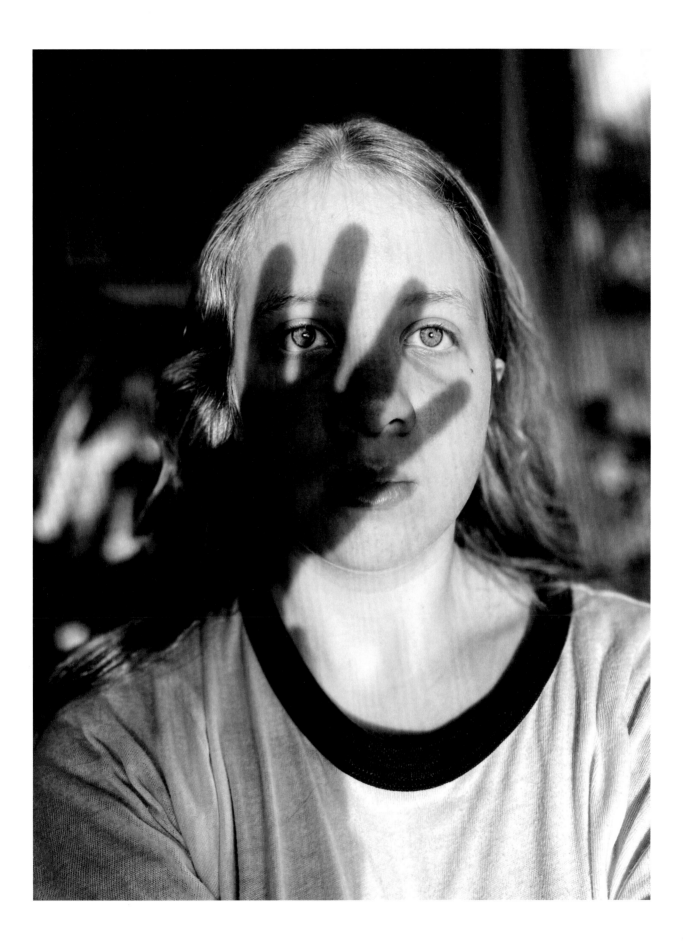

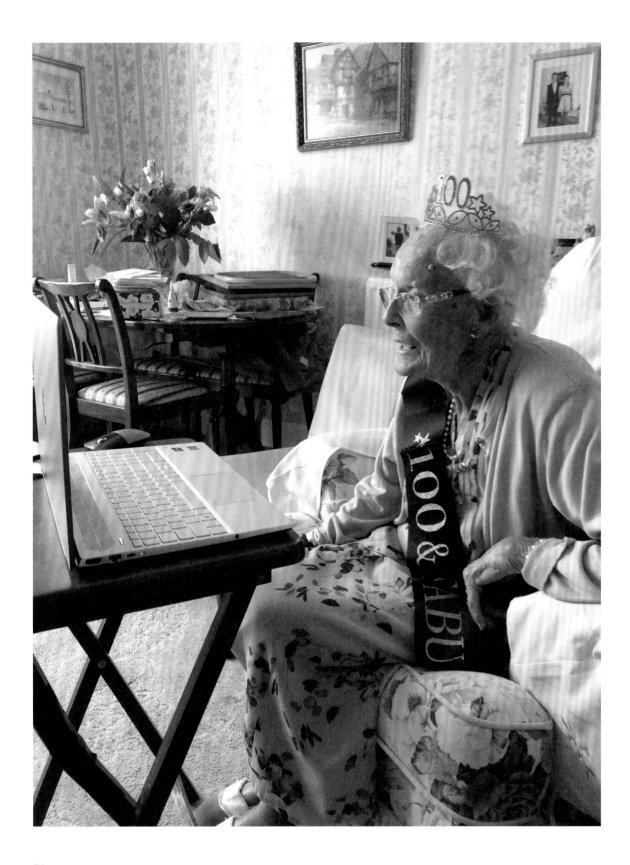

MUM'S 100TH BIRTHDAY
LOCKDOWN CHAT

BY ANITA REILLY
SOUTHAMPTON, HAMPSHIRE

This image shows my mum's excitement on her 100th birthday at having received a card from Her Majesty The Queen, with whom she shares her birthday, and celebrating by chatting on the computer video with all the family during the coronavirus lockdown.

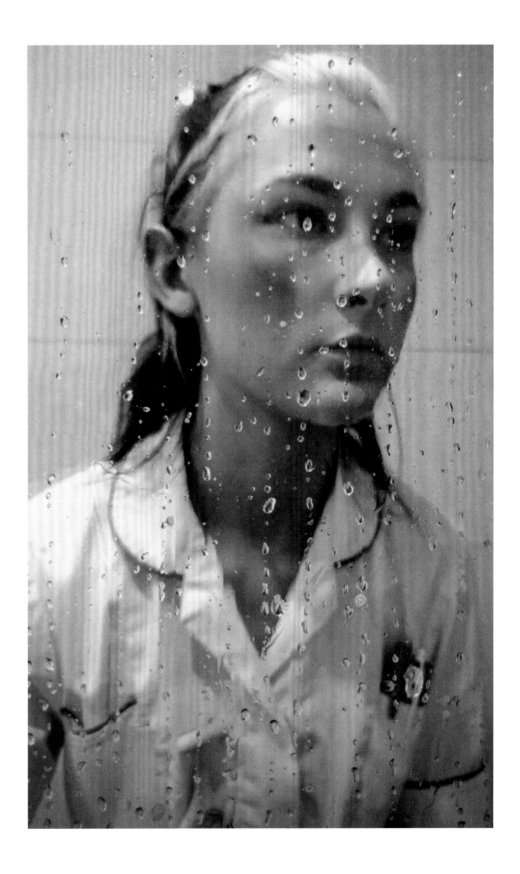

82

THE STRUGGLE

**BY JOY
(AGED 15 YEARS)**
NOTTINGHAM

Across lockdown we have all struggled for many different reasons. However, seeing my sister as an 'opt-in' student nurse inspired me to try to reflect their struggles in an image. The emotions I have tried to portray are the feelings of isolation, fatigue, frustration, mourning and stress. I want people to look at this photo acknowledging and remembering the sacrifices our key workers have made.

IN THE WORKROOM OF
SUZANNA AND FLORENCE
SWERYDA

BY ALUN CALLENDER
BRIGHTON, EAST SUSSEX

Throughout the lockdown, Suzanna and her daughter Florence have been working together to make scrubs for the NHS in collaboration with the Brighton Scrub Hub. As part of my reaction once lockdown restrictions were relaxed, I made portraits of makers and craftspeople who have been making scrubs and PPE for the NHS and key workers. It was also important for me to get back to work and learn to make portraits in a socially distanced way. This image was made with the doors open at the end of Suzanna's workroom whilst I stood in the garden. It was a moment of calm as they were working on their latest batch of scrubs.

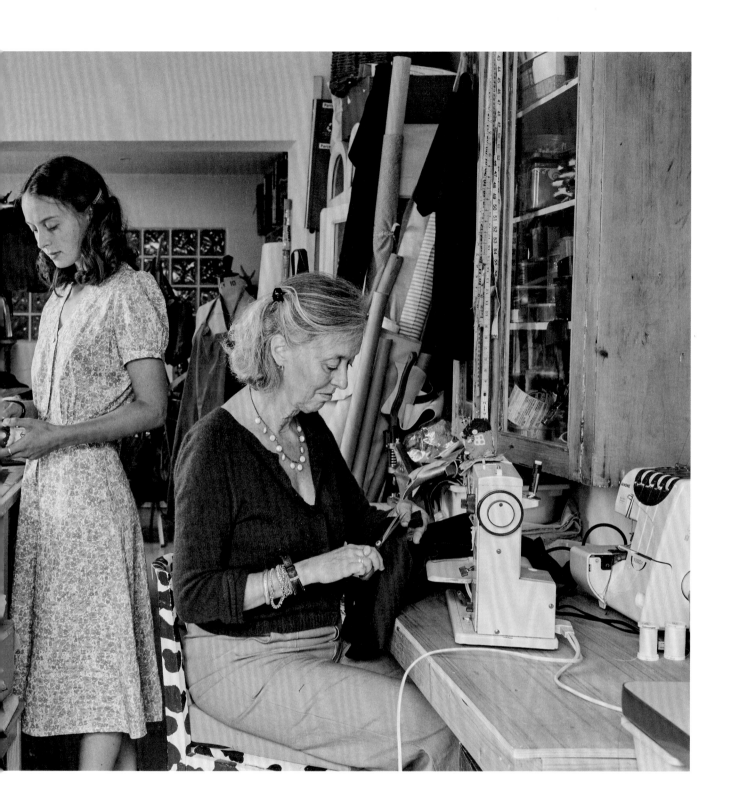

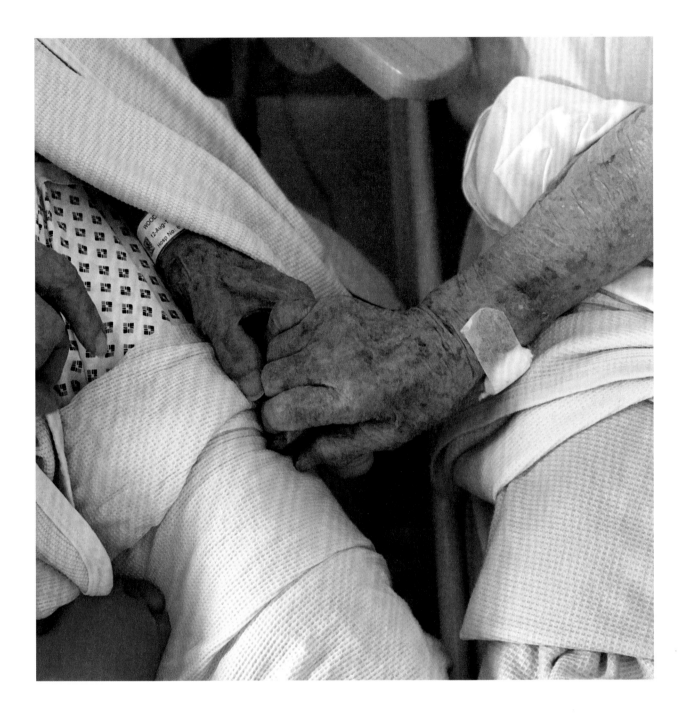

My grandparents, Pat and Ron Wood, were married 71 years ago on St George's Day. In May 2020, they were admitted a week apart to the Covid ward at Worthing Hospital. At first they were nursed separately, but were soon reunited. Kind staff pushed their beds together and gave them their own room. They spent their final days exactly where they were meant to be and exactly how they had spent the last 71 years ... together. Pat passed away in her sleep, lying next to her dear Ron, and he followed her five days later. Together, forever holding hands.

They appreciated the tiny things and took nothing for granted. The ability to touch when they had so little left was a gift. It was the only way to show their love and devotion. I took this photo with gloved hands looking through a visor. It gives me so much comfort to know, in a world where we have to distance ourselves from each other, that they had everything they ever wanted in the palm of their hands. This was the last time I saw them.

FOREVER HOLDING HANDS

BY HAYLEY EVANS
WORTHING, WEST SUSSEX

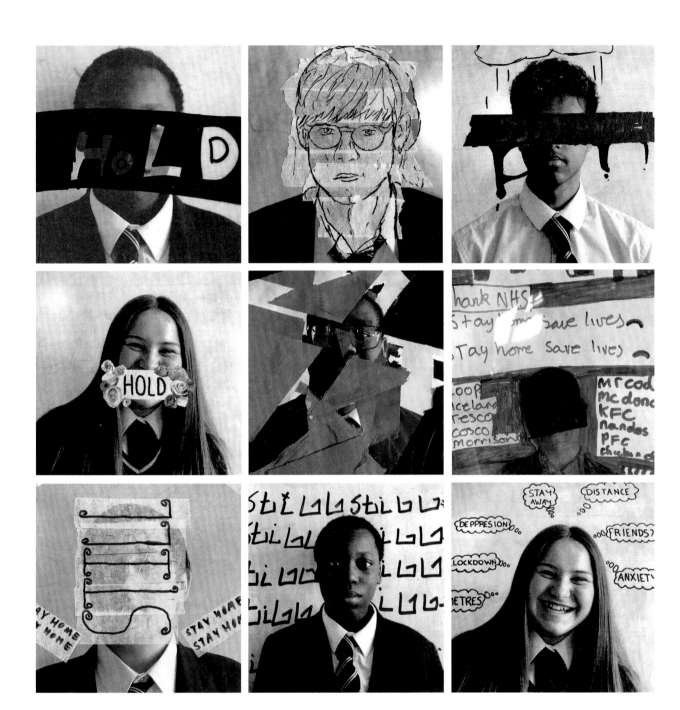

IN SCHOOL: STILL HERE

**BY STUDENTS FROM MAIDEN ERLEGH SCHOOL
(AGED 13–15 YEARS)**
READING

This is a series of images by students from Maiden Erlegh School. These students have come to school every day during lockdown. Life isolated at school is their new normal. We asked them how they felt about this life and asked them to 'destroy' their portraits to capture their mood. This is their collective response.

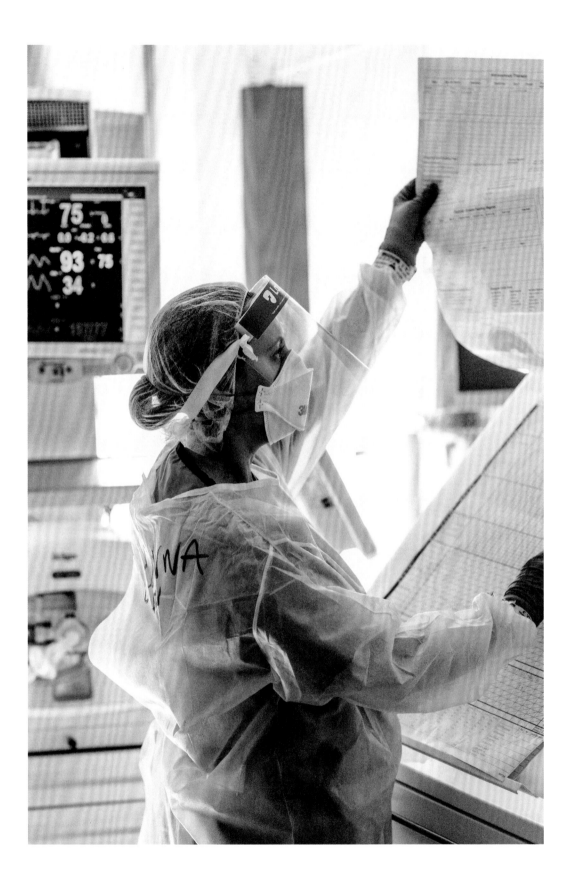

BEHIND CLOSED DOORS

BY ALEXANDER SCOTT
MIDDLESBROUGH

The COVID-19 crisis has hit intensive care units particularly hard. Much of the work done there is hidden by the necessities of safety, but the care and professionalism of ITU workers should be documented and remembered. The picture displays a staff nurse carefully observing the trends in observations of her patient whilst wearing full PPE in a COVID-19 intensive care unit in the James Cook Hospital.

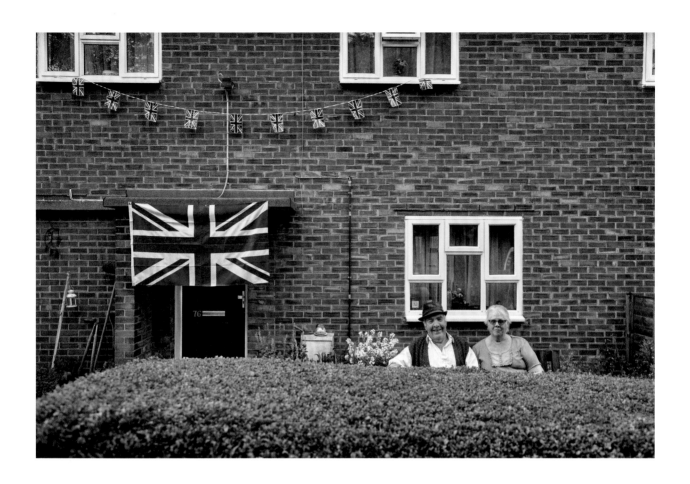

87

MICK AND MAVIS

BY CHRIS FRAZER SMITH
ASHWELL, HERTFORDSHIRE

I shot this on the commemoration of VE Day when it felt like a release from the COVID-19 lockdown and the atmosphere became more upbeat. Mick and Mavis were born and grew up in our village and they are well known within the community. I often see Mick and Mavis sitting behind their hedge watching the world go by or tending to their garden. The hedge became the perfect metaphor for social distancing and they were very happy to have their portrait made on a warm English evening, celebrating VE Day.

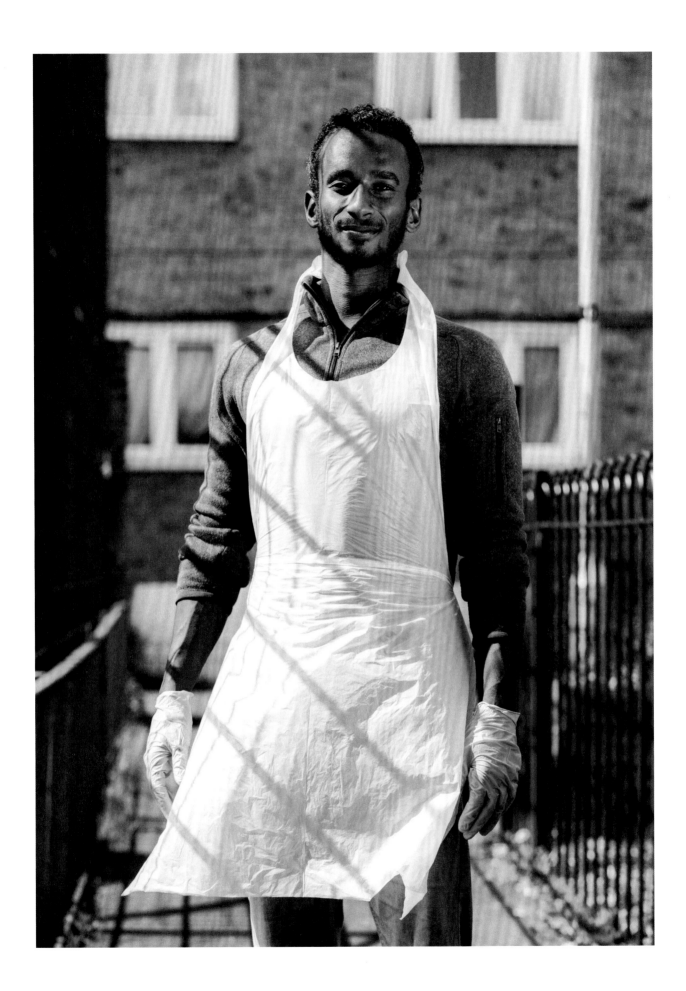

I met Sami on his first day of volunteering at the Children With Voices Community Food Hub in Hackney, London. Originally from Sudan and raised in Brazil, Sami came to the UK for his PhD and had just moved into an apartment overlooking the food hub. He saw what was happening and came down to lend a hand. I was drawn to his beaming smile and positive vibe. I love the way his apron flutters in the wind, cape-like, as if revealing for a moment the superhero within. It's everyday acts of kindness and solidarity like Sami's that have brought communities together through this crisis.

This portrait is part of a larger project documenting volunteer support networks in Hackney during the pandemic. Food banks like this one, sustained by volunteers giving their time to help their neighbours, have become a lifeline for countless people in the borough and across the country. Their tireless work deserves recognition and support so they can continue to serve their communities.

88

SAMI

BY GREY HUTTON
LONDON

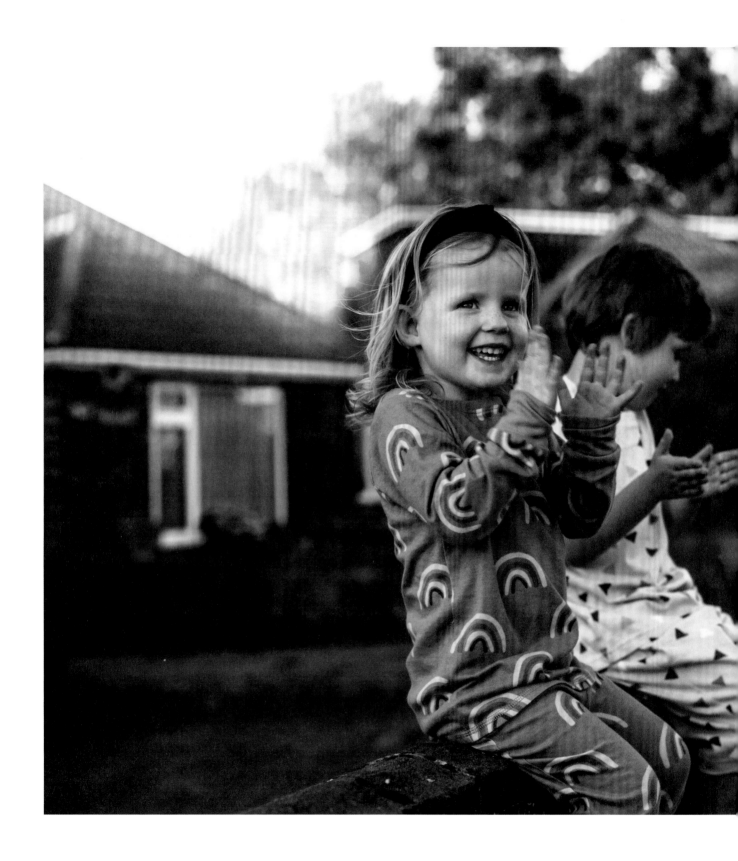

89

**CLAPPING FOR MUMMY &
DADDY (OUR HEROES)**

BY NICOLE PAIGE WALTERS
SOUTHAMPTON, HAMPSHIRE

Thursday nights at 8pm held a new meaning in the UK, with clapping for the NHS, carers and all the key workers out there. With rainbow pyjamas on, Iris and Lucas set their sights on clapping louder than the whole street and yelling, 'THANK YOU MUMMY AND DADDY.' Being frontline workers is hard but rewarding, and seeing your children so proud of you makes it all even more worthwhile.

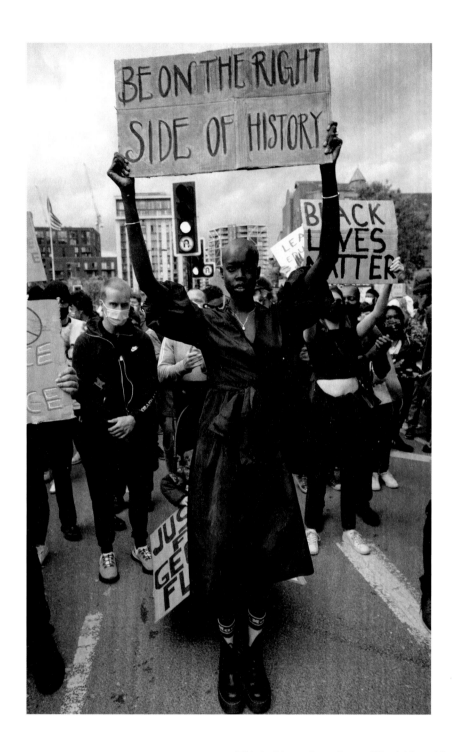

This is Akuac. I met her at Black Lives Matter protest at the US Embassy in London and asked to take her picture, so she took off her mask and stood for me. We've been friends since and I hope we will be for many years to come. Her strength and spirit is beautiful and unique. For me, the image reminds us that all of ours are. Every single one. George Floyd. Breonna Taylor. The countless others that we know of and that we don't. I hope that the new normal after COVID-19 is kindness, equality, compassion, love. I hope the new normal is really seeing what's important – looking after each other and the planet. If this pandemic has taught us anything, it must be that all we need really is the well-being of our loved ones. It wasn't shopping centres, or flights around the world or buildings that we were used to socialising in that we really missed in lockdown – it was humans. Our human connection is the most important thing we have. I hope that we can keep this feeling going far beyond 2020.

90

AKUAC

BY ANASTASIA ORLANDO
LONDON

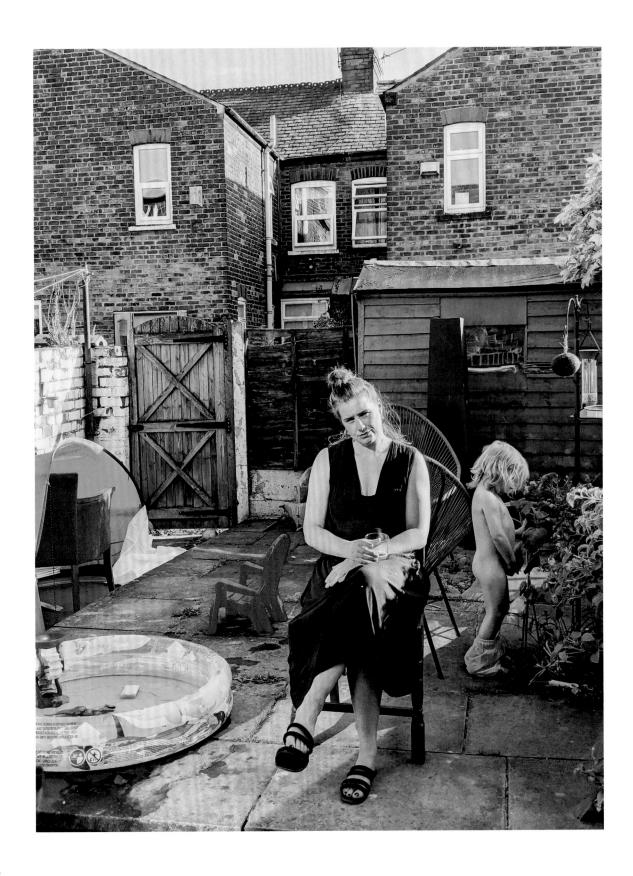

**WE'RE REALLY LUCKY TO
HAVE A GARDEN**

BY ROBERT COYLE
SALE, MANCHESTER

The weekend is here, lockdown continues and Bernadette and Francis enjoy the garden. One Friday, as I finished emailing at the kitchen table, my wife had taken a chair and a drink outside to enjoy the evening sun. We were doing our best, like the rest of the country, with work, childcare and news of daily death tolls. Our son had taken to relieving himself on the plants, much to our initial amusement and then slight frustration.

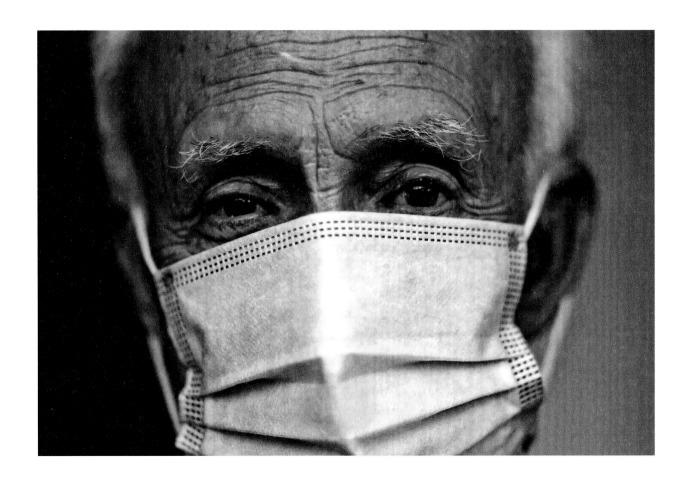

IN FAMILY WE TRUST

BY NINA ROBINSON
NEWCASTLE-UNDER-LYME,
STAFFORDSHIRE

My 86-year-old grandad is a survivor of the Hungarian Uprising and took asylum in the UK in 1956. Even though he's lived here for all these years, English is not his first language, and the information in the media about coronavirus does not always translate easily. It is up to us, his family, to turn this news into advice he can understand. It is us he relies on for information on keeping safe and we value this sense of responsibility to care for him. We are the ones who explain that we can't hug him, that he has to wear a mask and that he can't have his hair cut. In us, he trusts. A few weeks after taking this photograph, my grandad was diagnosed with cancer, which changes my outlook on the image now that I look back at it. He had it then, but he didn't know and neither did I. I'm overjoyed that he's made it into this project.

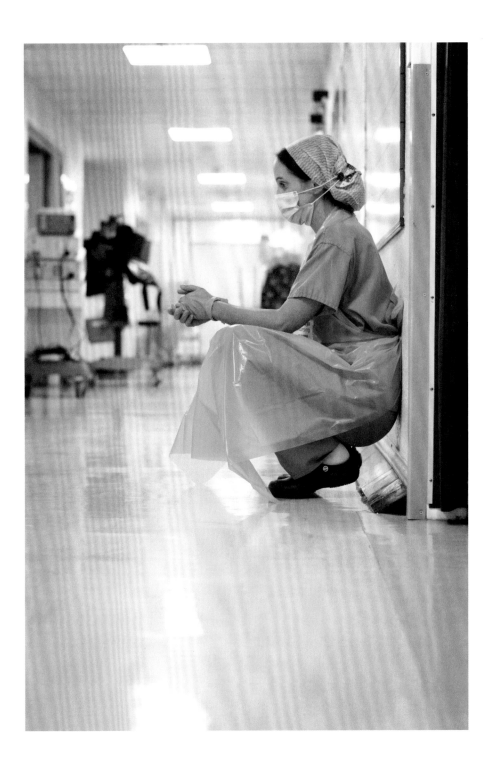

I approached the Aneurin Bevan Health Board at the beginning of February with a view of documenting the pandemic photographically and was extremely grateful to be given permission. The NHS has never been under so much pressure and I wanted to capture every minute possible while also working on the frontline myself. The pandemic hit my hospital like a tsunami. I witnessed friends and colleagues breaking down. Physically and mentally. This wasn't a moment of weakness though. This was my friend getting ready to 'go again'. This showed the determination that every single key worker has. That Britain has. She rose to her feet moments later, donned her PPE and took on the pandemic head first. Proud to be part of the National Health Service. Proud to be a key worker. Proud to be British.

The photographs were published in my book *Behind the Mask* and sold thousands of copies, raising money for the NHS and Wales Air Ambulance.

HERO

BY GLENN DENE
ABERGAVENNY,
MONMOUTHSHIRE

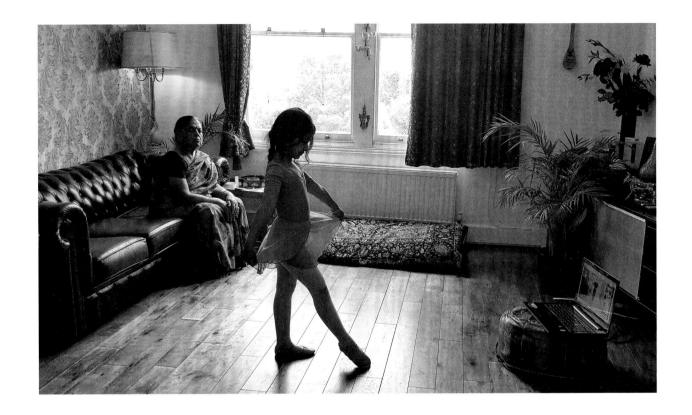

**SISTER ATTENDING ONLINE
BALLET CLASS**

**BY VEDANT
(AGED 12 YEARS)**
LONDON

Before the pandemic, my sister Aurelie went to ballet class once a week. But because of lockdown she cannot do so. So, she is now doing her ballet class over Zoom. I find it unremarkable now but, few months back, no one would have thought to do it this way. This image was taken while she was practicing ballet in our London home and my grandmother is watching her.

The picture has lots of contrasts: my Indian grandmother wears a sari and watches my younger sister dancing a western dance in a western ballet dress. It also shows different generations and future technology co-existing in our modern English house. Looking back at the photograph now, I feel this new way of living is going to stay for a while.

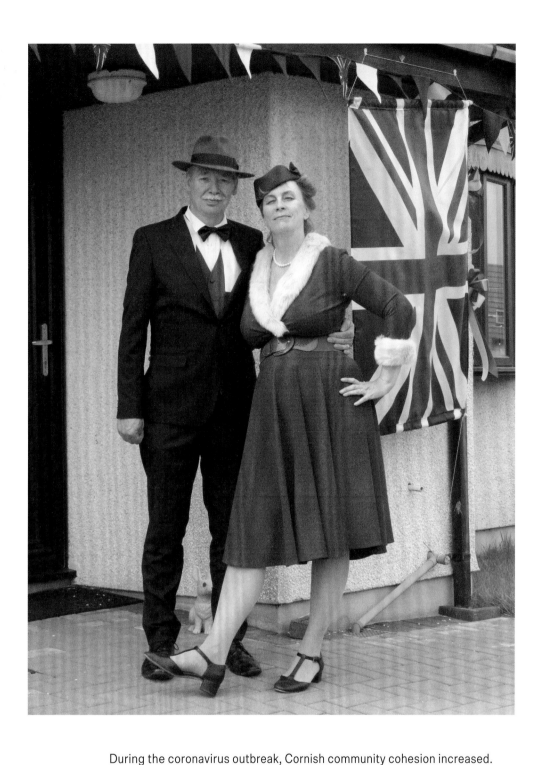

**A BRIEF PERIOD OF
REJOICING**

BY JOCELYN MURGATROYD
DELABOLE, CORNWALL

During the coronavirus outbreak, Cornish community cohesion increased. The 75th anniversary of VE Day fell during the most intense period of lockdown when everyone was at home. The media had convinced us that the wartime spirit, which enabled Britain to come together during the Second World War, was the same as that needed to overcome COVID-19. In Delabole, Union Jacks and bunting joined the rainbows and NHS thank yous. We were all eager to have a good time, but sometimes movers and shakers are needed to get the party started. Catherine and Vincent Henstock organised a socially distanced street party in Park Pennkarn. The sound of 1940s music lured me into the cul-de-sac and I found virtually every inhabitant sitting outside their respective houses, eating wartime party food and dressed in period clothes. A Second World War quiz was held with bananas as the prize and everyone stood to hear Vincent re-enact Winston Churchill's speeches. This remains my favourite memory, as it celebrated connectedness, survival and hope.

HIGHER LEARNING

BY CLAUDIA BURTON
LONDON

This is my son doing home-schooling in our small outdoor space, the balcony. This is currently our new normal. We live in a two-bedroom, third floor flat in London. Space is limited, and with schools closed we tried to make as much use as possible of the outdoor space that we have. My son enjoys being at school and learning new things, so 'lockdown learning', above the heads of fellow residents and passers-by, was amusing and interesting to him and kept him engaged.

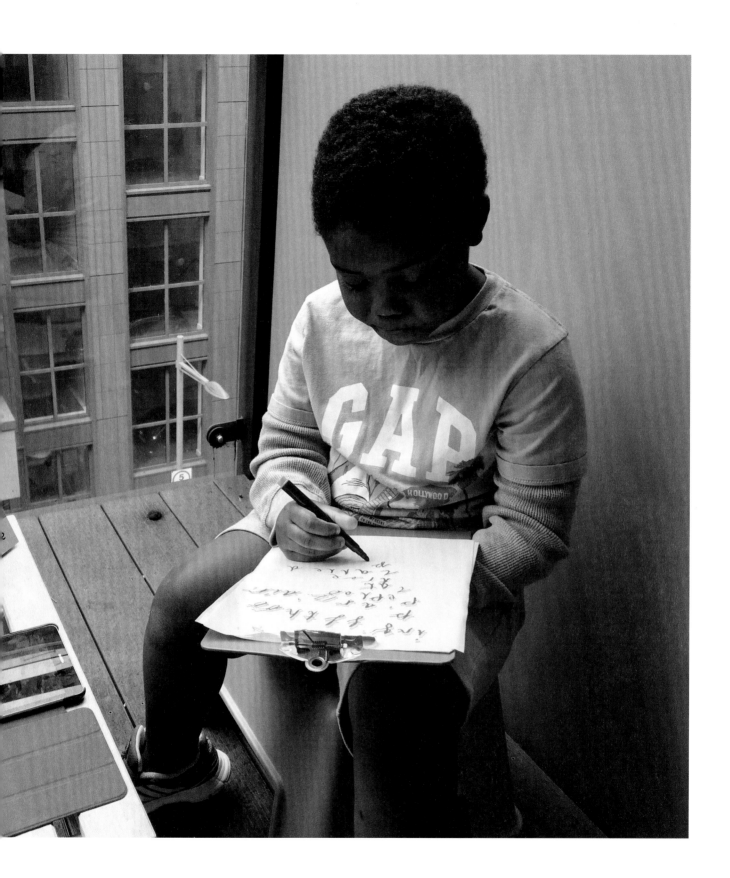

'WE WILL WORK THROUGH THIS, TOGETHER, IN THE MOST CO-OPERATIVE, RESPONSIBLE AND COMPASSIONATE WAY WE CAN.'

I wrote these words to my Co-op colleagues last March as the UK was plunged into its first lockdown. Whilst all of our lives changed overnight, Co-op's work in supporting communities right across the UK became more important than ever.

I am incredibly proud that our Co-op played a part in bringing *Hold Still* to communities up and down the country.

British towns and cities from Belfast to Baldock, Cardiff to Cheltenham and Glasgow to Gidea Park became vast outdoor canvases in which hundreds of images of lives in lockdown became visible to us all.

And, impossible to forget, the powerful image of *Melanie* that was painted from the original right in the heart of Manchester's Northern Quarter and said so much of the sacrifice of our NHS workers.

Now, the accompanying *Hold Still* publication has forever captured the hope, hardship, kindness and cooperation that we all felt during those often difficult days.

Hold Still also carries another valuable legacy – one which has never before been more important. The proceeds from the sale of the book will support both the National Portrait Gallery and the incredible work carried out by Mind, an organisation very close to Co-op's heart that works so hard to ensure that people and communities get the support they need for their mental health and well-being when things feel like they are getting too much.

As we look ahead with renewed optimism, I am hopeful that, long after this pandemic passes, the community spirit and cooperation that it has ignited will live on for many years to come.

During this extraordinary period, our 60,000 Co-op key workers helped to feed the nation, cared for those we lost, provided support through insurance and legal services, and delivered practical help and medicine to vulnerable people and those isolating in our local communities.

Along with the healthcare teams, carers, teachers and delivery drivers across the nation, my colleagues' outstanding contribution was made possible because the rest of us held still.

STEVE MURRELLS
CO-OP, GROUP CEO

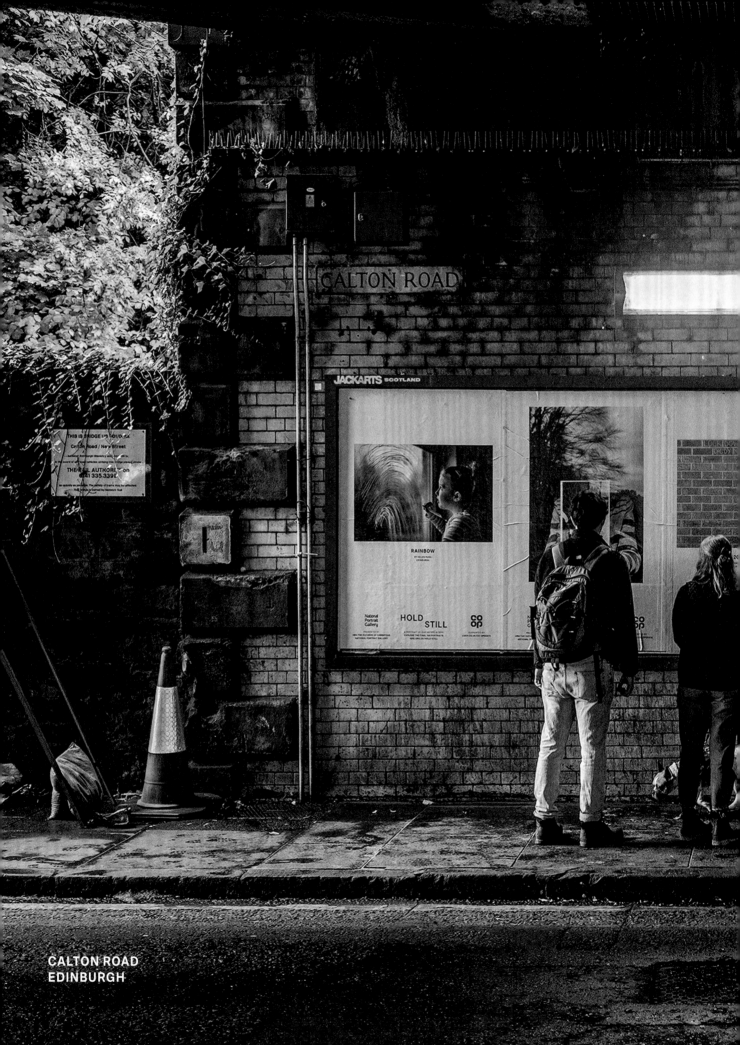

CALTON ROAD
EDINBURGH

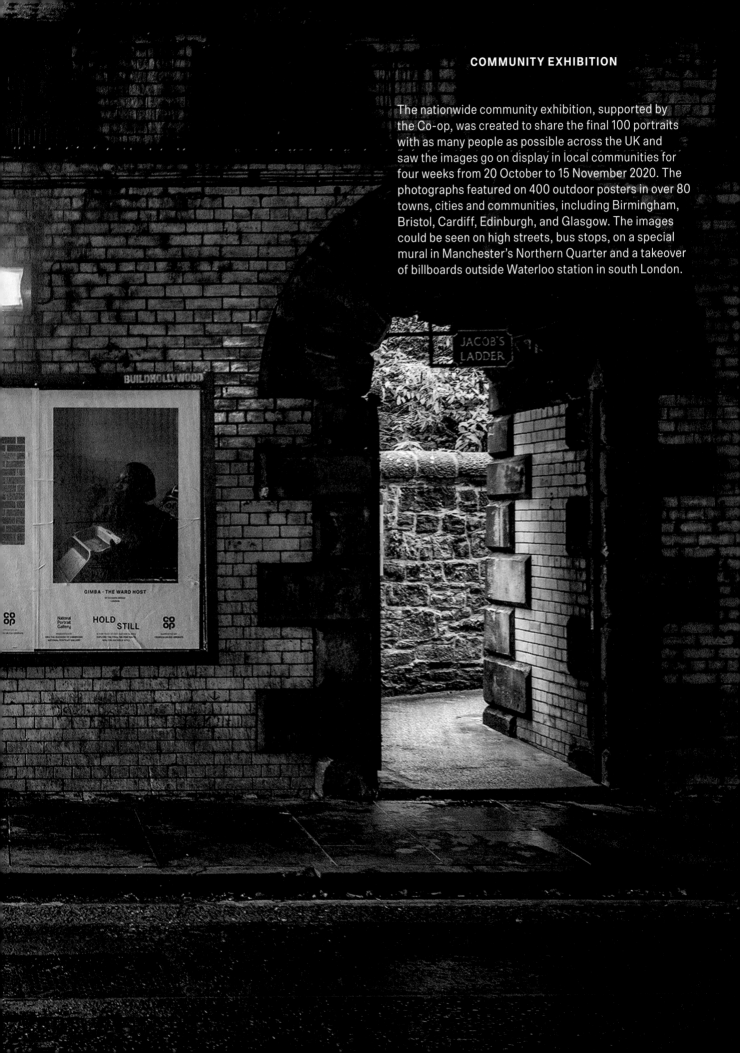

COMMUNITY EXHIBITION

The nationwide community exhibition, supported by the Co-op, was created to share the final 100 portraits with as many people as possible across the UK and saw the images go on display in local communities for four weeks from 20 October to 15 November 2020. The photographs featured on 400 outdoor posters in over 80 towns, cities and communities, including Birmingham, Bristol, Cardiff, Edinburgh, and Glasgow. The images could be seen on high streets, bus stops, on a special mural in Manchester's Northern Quarter and a takeover of billboards outside Waterloo station in south London.

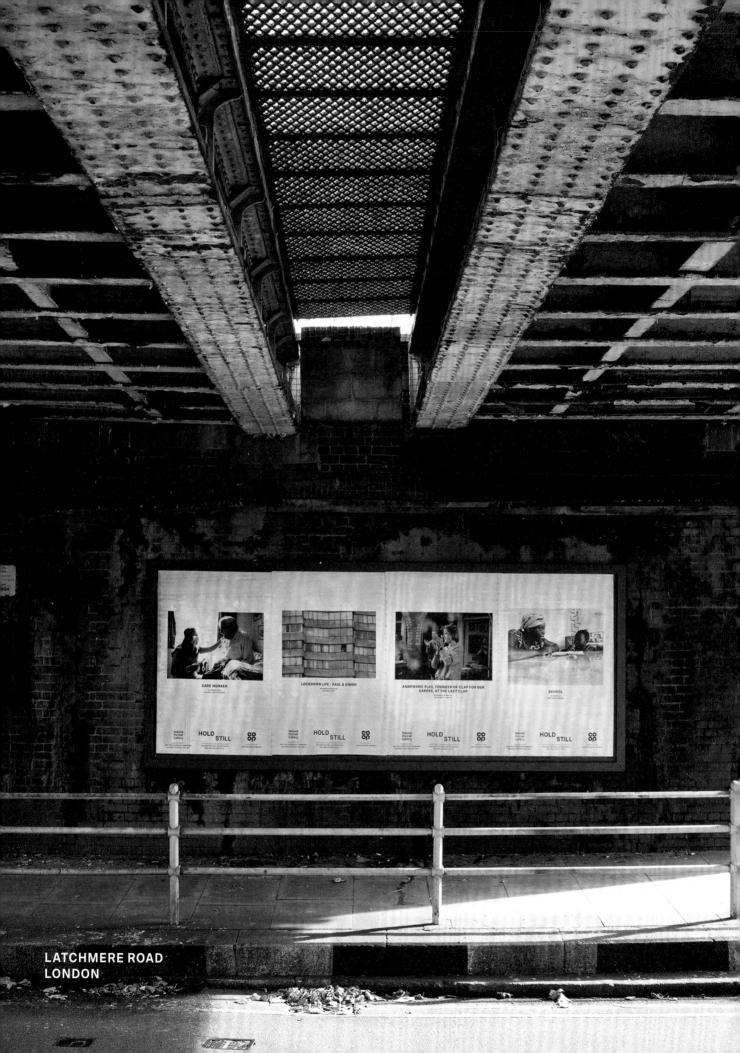

LATCHMERE ROAD
LONDON

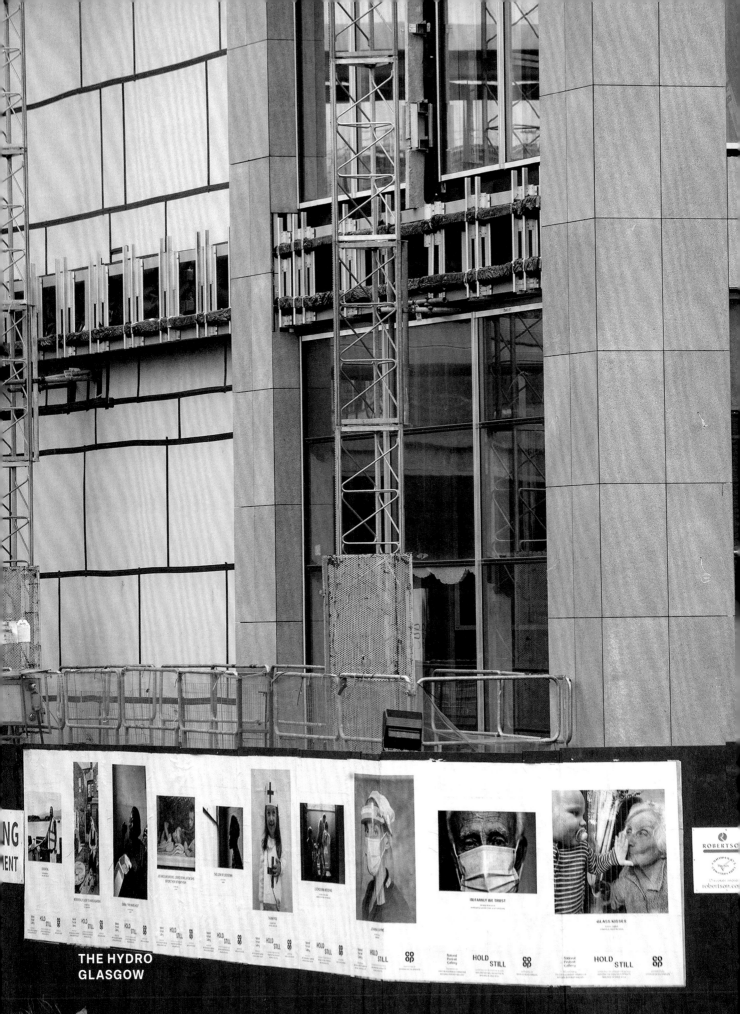

THE HYDRO
GLASGOW

DADI'S LOVE

BY SIMRAN JANJUA
LONDON

**JOE AND DUKE BROOKS, LOCKED DOWN, A FEW DAYS
BEFORE THEIR 18TH BIRTHDAY**

BY SARAH LEE
LONDON

National Portrait Gallery

HOLD STILL

CO OP

PRESENTED BY
HRH THE DUCHESS OF CAMBRIDGE
NATIONAL PORTRAIT GALLERY

A PORTRAIT OF OUR NATION IN 2020
EXPLORE THE FINAL 100 PORTRAITS
NPG.ORG.UK/HOLD-STILL

SUPPORTED BY
COOP.CO.UK/CO-OPERATE

National Portrait Gallery

HOLD STILL

CO OP

PRESENTED BY
HRH THE DUCHESS OF CAMBRIDGE
NATIONAL PORTRAIT GALLERY

A PORTRAIT OF OUR NATION IN 2020
EXPLORE THE FINAL 100 PORTRAITS
NPG.ORG.UK/HOLD-STILL

SUPPORTED BY
COOP.CO.UK/CO-OPERATE

**BATTERSEA PARK STATION
LONDON**

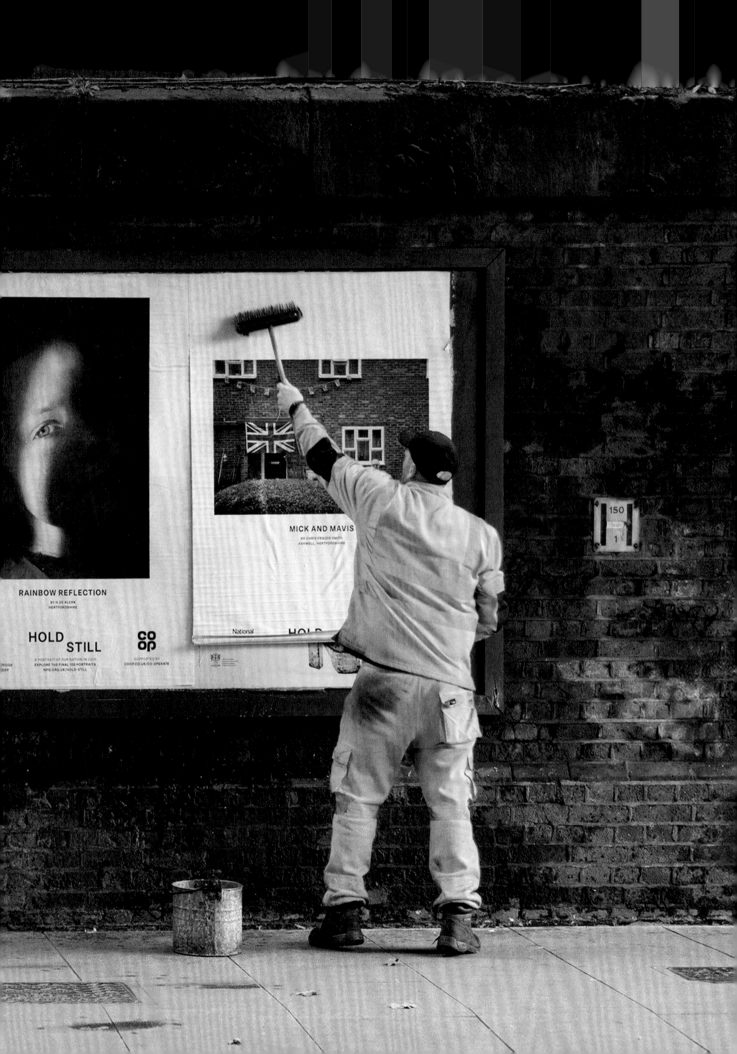

BITTERNE ROAD
SOUTHAMPTON

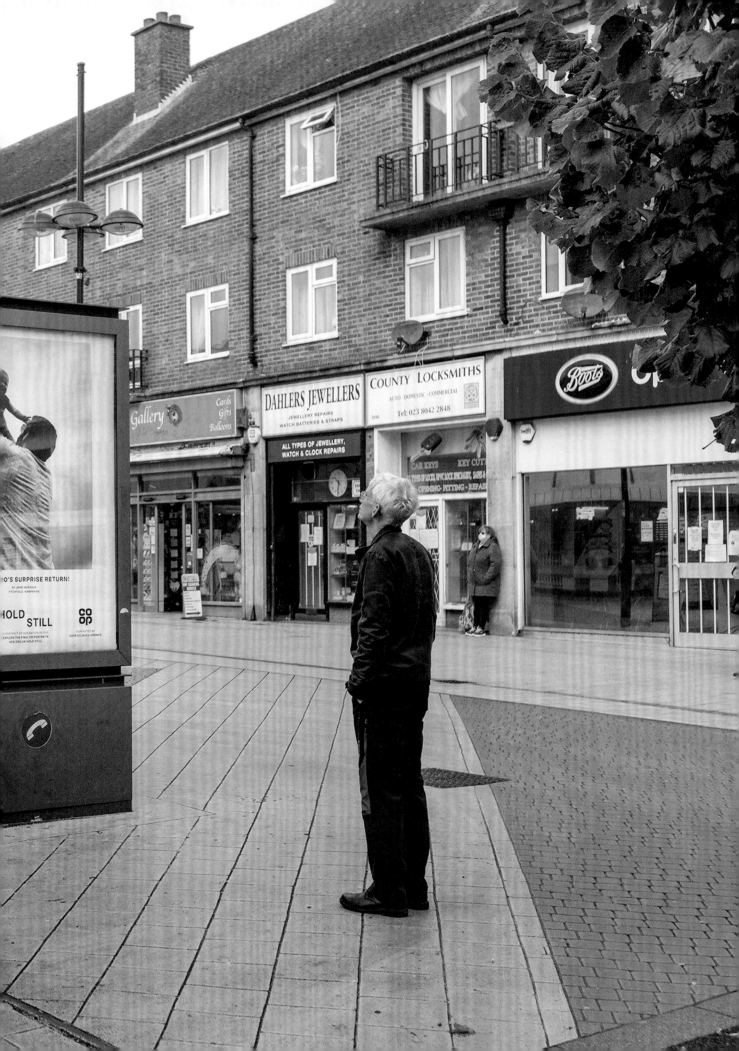

WATERLOO
LONDON

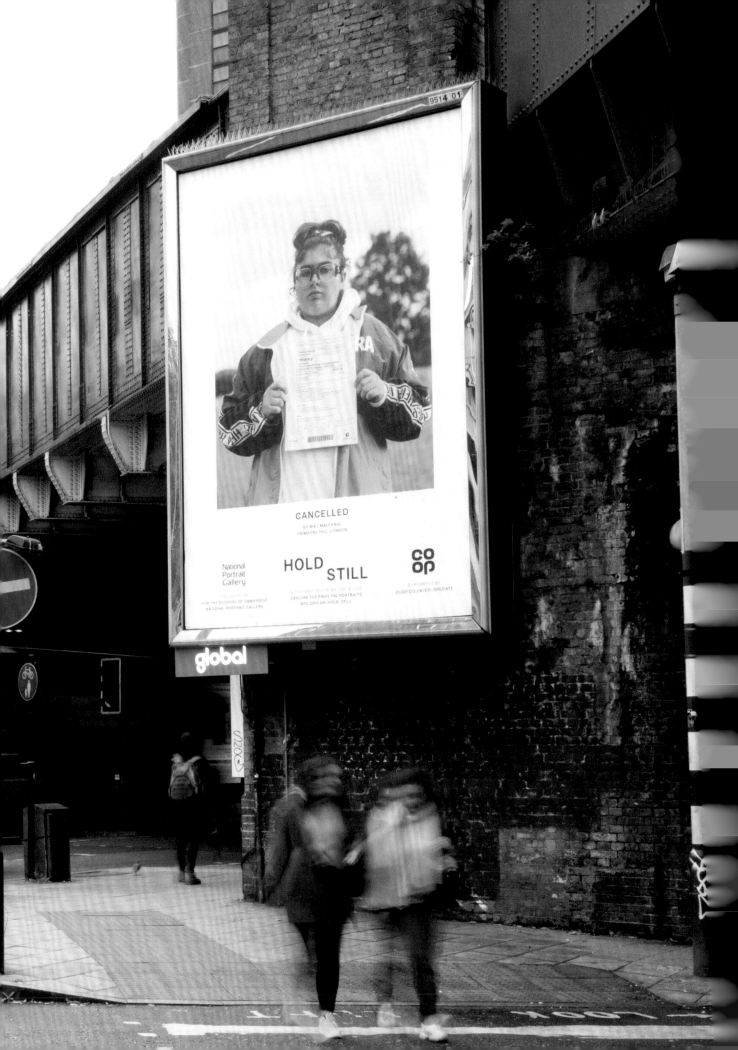

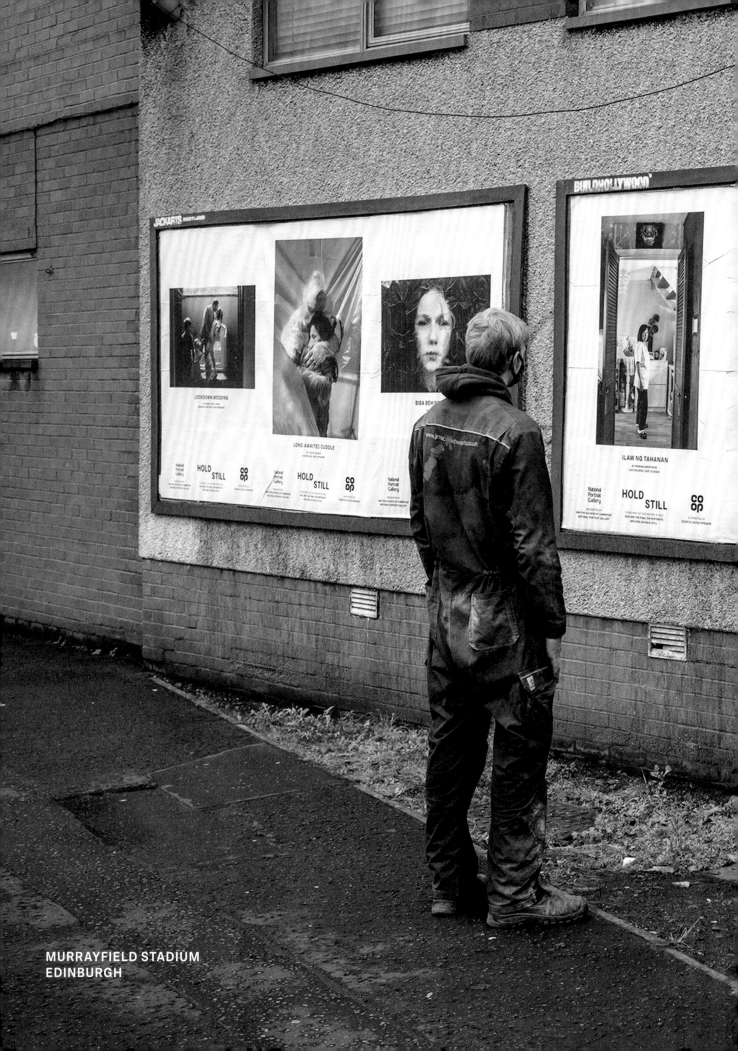

MURRAYFIELD STADIUM
EDINBURGH

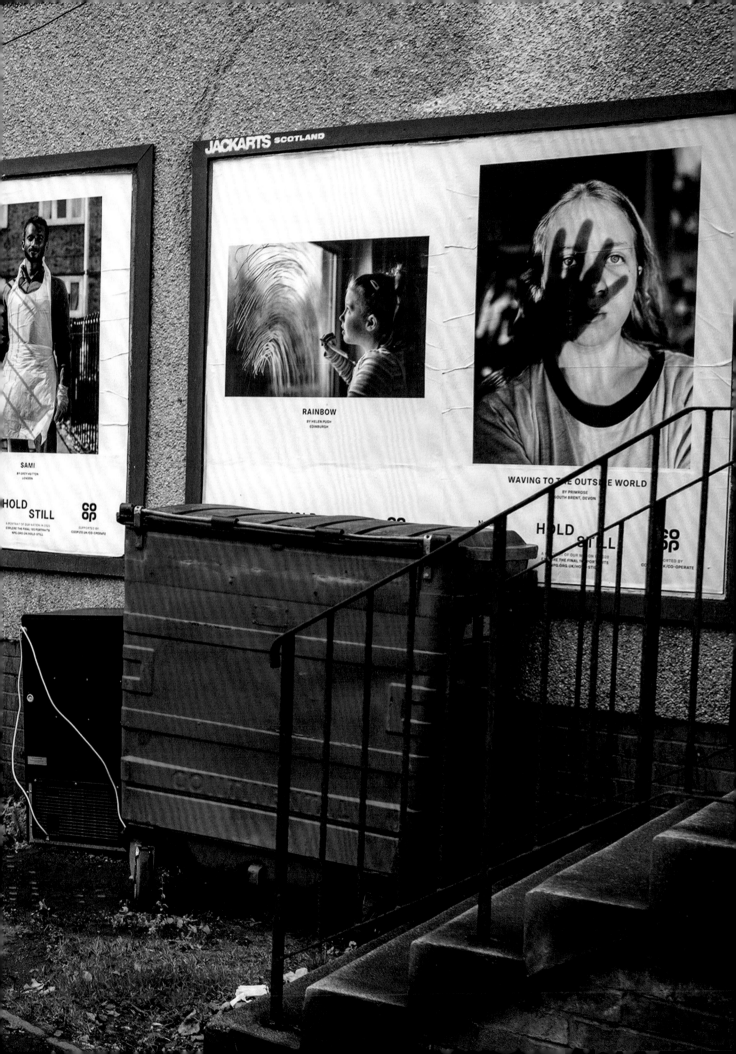

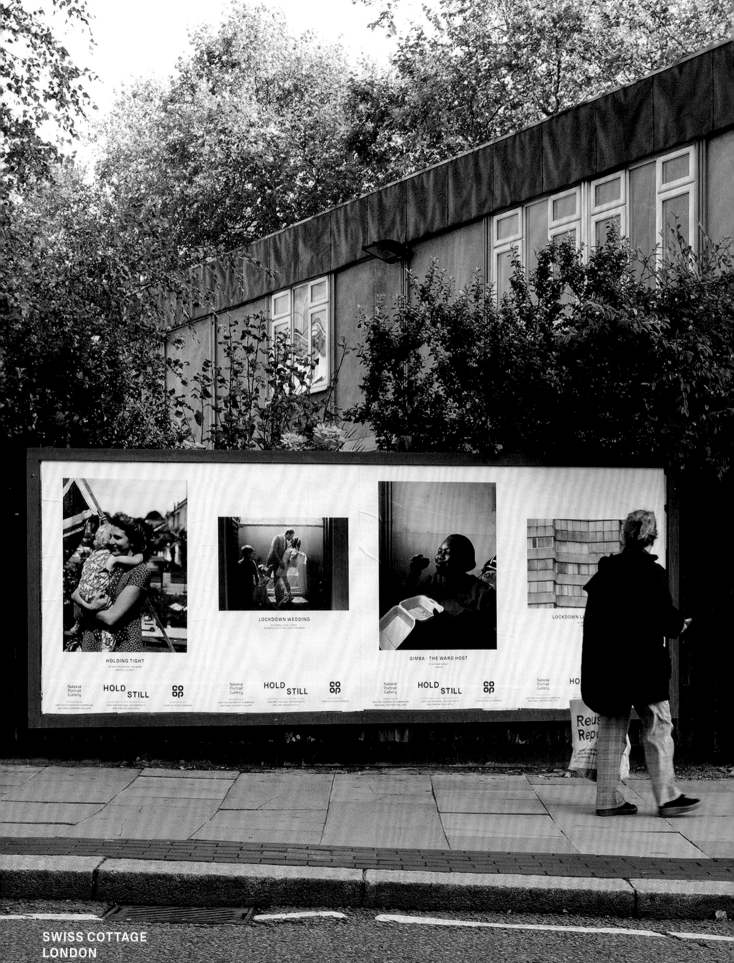

SWISS COTTAGE
LONDON

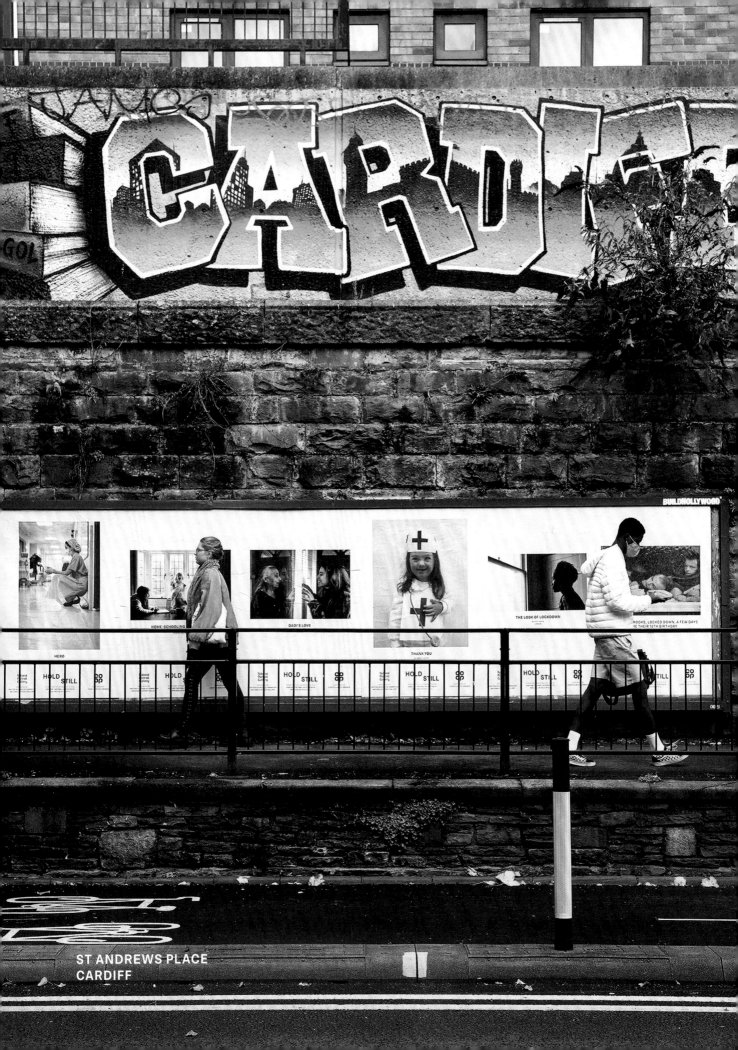

ST ANDREWS PLACE
CARDIFF

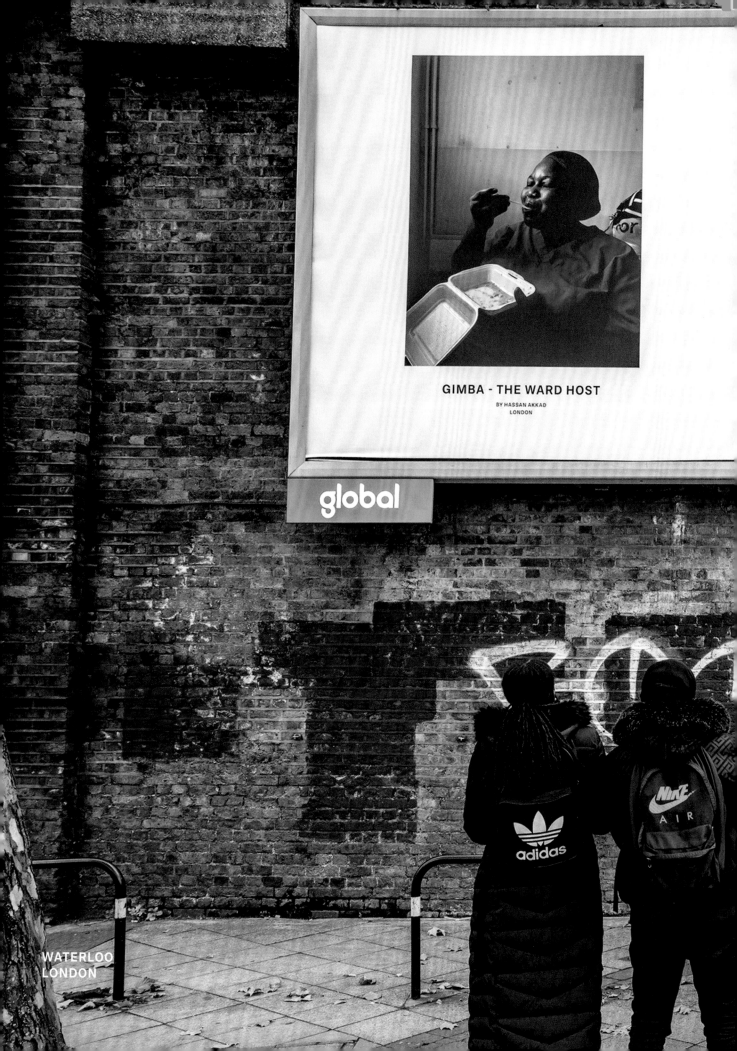

GIMBA - THE WARD HOST

BY HASSAN AKKAD
LONDON

global

WATERLOO
LONDON

ESSENTIAL

BY CHRISTOPHER COX
OBAN, ARGYLL AND BUTE

HOLD STILL

A PORTRAIT OF OUR NATION IN 2020
EXPLORE THE FINAL 100 PORTRAITS
NPG.ORG.UK/HOLD-STILL

National
Portrait
Gallery

PRESENTED BY
THE DUCHESS OF CAMBRIDGE
NATIONAL PORTRAIT GALLERY

CO
OP

SUPPORTED BY
COOP.CO.UK/CO-OPERATE

450201

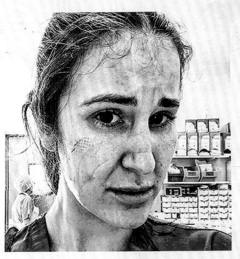
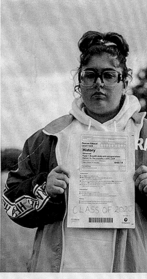

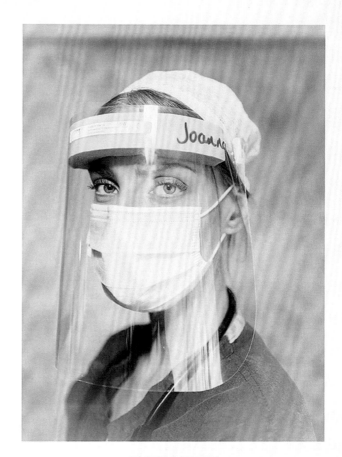

JOANNA IN PPE

BY HARRY HALL
CAMBRIDGE

National
Portrait
Gallery

**BURLEIGH STREET
CAMBRIDGE**

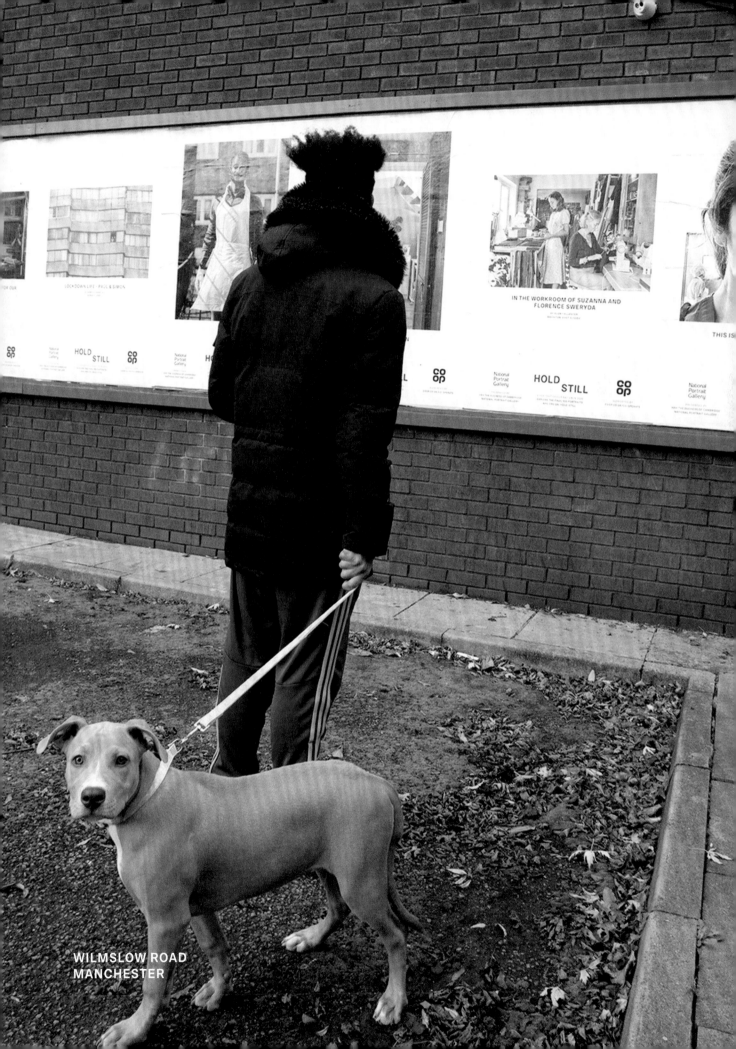

WILMSLOW ROAD
MANCHESTER

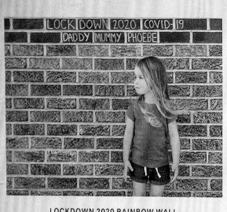

ST LEONARDS
EDINBURGH

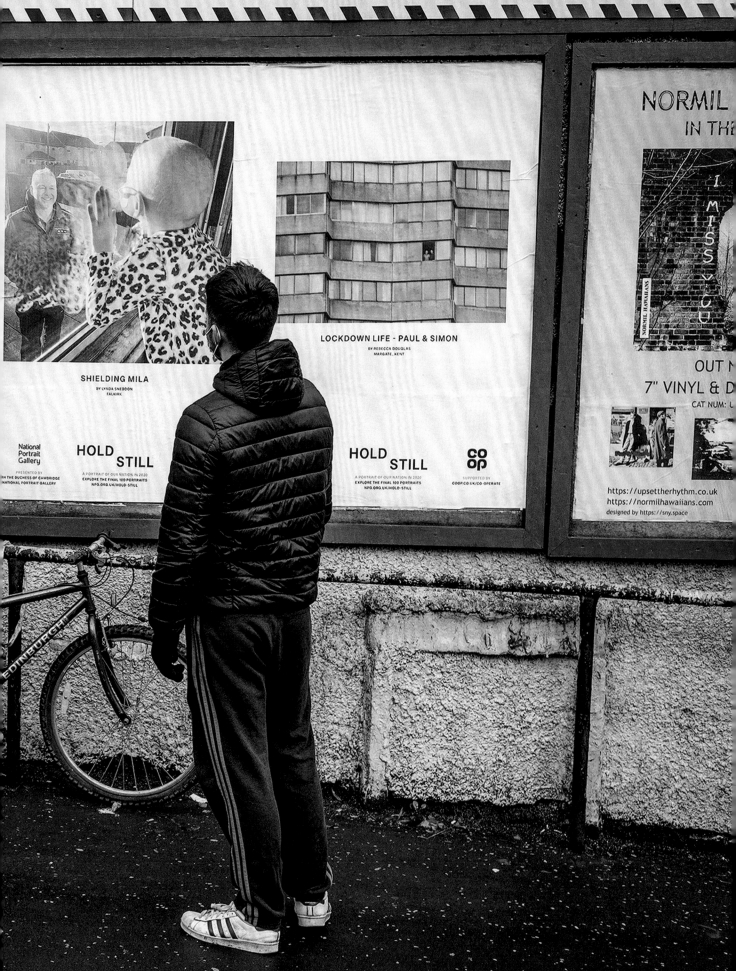

NORTHERN QUARTER
MANCHESTER

MELANIE, MARCH 2020
BY JOHANNAH CHURCHILL

National
Portrait
Gallery

HOLD STILL

CO·OP

MELANIE, MARCH 2020
BY JOHANNAH CHURCHILL

HOLD
STILL

CO
OP

A PORTRAIT OF OUR NATION IN 2020
EXPLORE THE FINAL 100 PORTRAITS
NPG.ORG.UK/HOLD-STILL

SUPPORTED BY
CO-OP.CO.UK/CO-OPERATE

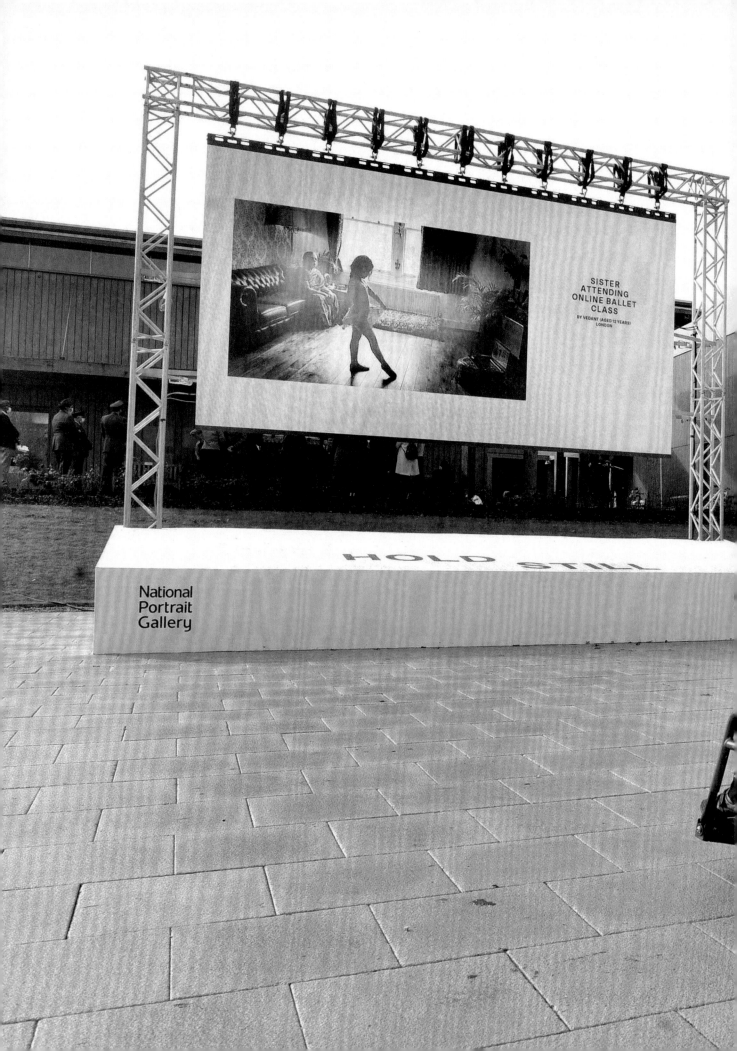

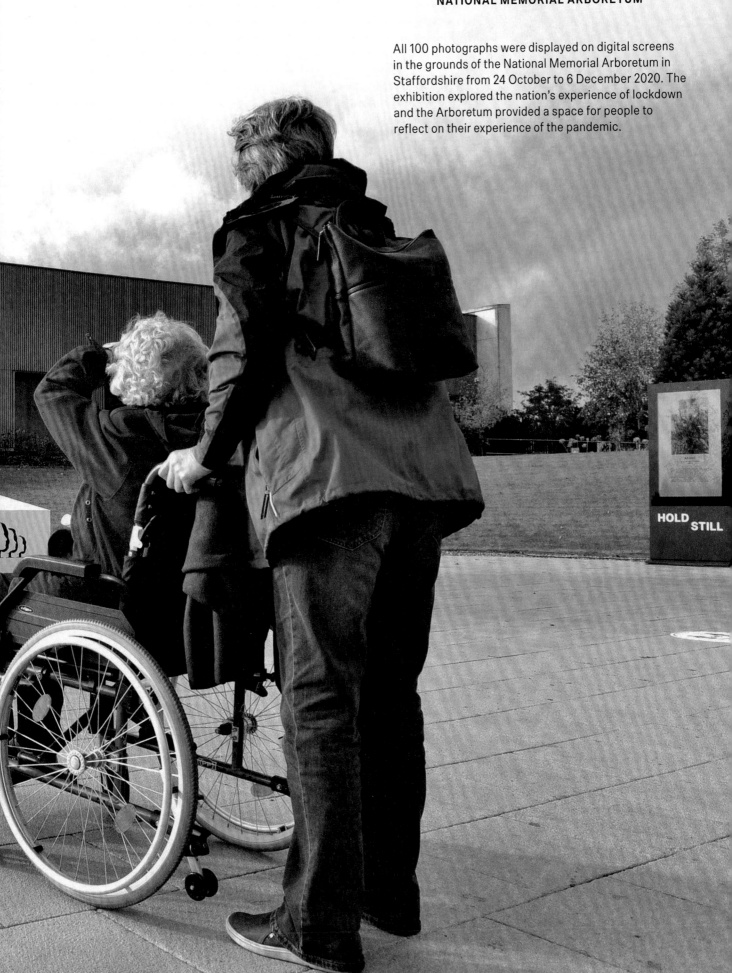

NATIONAL MEMORIAL ARBORETUM

All 100 photographs were displayed on digital screens in the grounds of the National Memorial Arboretum in Staffordshire from 24 October to 6 December 2020. The exhibition explored the nation's experience of lockdown and the Arboretum provided a space for people to reflect on their experience of the pandemic.

HOLD STILL

Felt so privileged to able to view my photo in the *Hold Still* exhibition at the National Memorial Arboretum today.

No, I wasn't waiting for a bus, just found my image displayed at the bus stop!

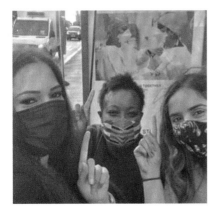

Just a photo of me next to a photo of me.

Hey look! We're on a bus stop.

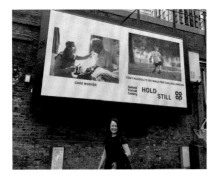

The closest thing to being cared for is to care for someone else. So proud to see my picture in a billboard. Love my job!

This is a little bit of magic.

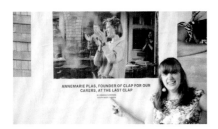

What's that? My photo is up on billboards all over the UK?

Today we went photo spotting in the rain!

#HOLD

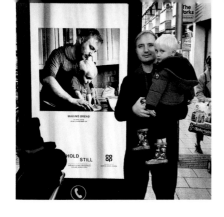

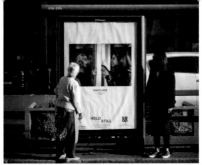

Dadi's Love – The gift that keeps on giving, in so many ways!

Absolutely blown away with everything going on at the moment. Proud to share this moment with my son.

So excited and proud to find my boys on a bus stop!!

2020

STILL

So proud of my sister, such a beautiful surprise during such tough times, so special that we get to share it with the world.

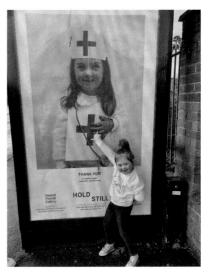

Yay the local ones are up outside the Park Hotel.

The gang went and checked out our *Hold Still* billboard in Staple Hill, Bristol.

ABOUT THE PROJECT

Spearheaded by The Duchess of Cambridge, Patron of the National Portrait Gallery, *Hold Still* was an ambitious community project to create a unique collective portrait of the UK during lockdown. People of all ages were invited to submit a photographic portrait, taken during a six-week period between May and June 2020, focused on three core themes: Helpers and Heroes, Your New Normal and Acts of Kindness.

Over 31,000 submissions were received from across the country, with entrants ranging from 4 to 75 years old. From these, a panel of judges selected 100 portraits. The judges assessed the images on the emotions and experiences they convey rather than on their photographic quality or technical expertise. Their aim was to select images that created a collective snapshot of the nation and reflect resilience and bravery, humour and sadness, creativity and kindness, human tragedy and hope.

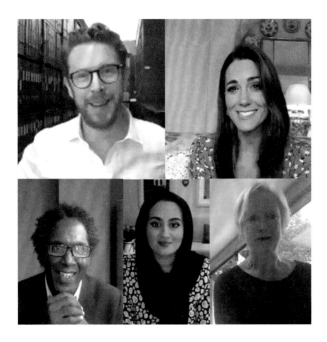

The *Hold Still* judges, clockwise from left to right: Nicholas Cullinan, Director, National Portrait Gallery; The Duchess of Cambridge, Patron of the National Portrait Gallery; Ruth May, Chief Nursing Officer for England; Maryam Wahid, photographer; Lemn Sissay MBE, writer and poet.

NATIONAL PORTRAIT GALLERY

The National Portrait Gallery is both for and about people. From Tudor portraits to the recent stories captured as part of *Hold Still*, we invite everyone to meet the people who have made – and are making – Britain what it is today.

We are a charity that relies on the support of the public to self-generate over 70% of the funds needed to care for and share our national Collection and provide free access, inspiration and learning to millions of people through our gallery in London, national programmes and digital channels.

Vital support from the public funds our activities with a wide range of audiences such as community groups and schools. Initiatives like Creative Connections, a national partnership project with regional venues that brings school children and artists together to explore the inspirational stories of people associated with their local community, and our long-running arts programme in London children's hospitals, which delivers creative workshops to provide comfort, enjoyment and distraction for young people while they are undergoing medical treatment.

Projects like these enable us to use our portraits to enrich people's lives and highlight the cultural, social and historical links that we all share, something that is more important now than ever. Proceeds from the sale of the book will contribute to these activities. To find out more about our work please visit npg.org.uk.

The National Portrait Gallery is recognised as a charity under the provisions of the Charities Act 2011.

MIND

We are Mind, the mental health charity. We won't give up until everyone experiencing a mental health problem gets both support and respect. We provide advice and assistance to empower anyone experiencing a mental health problem. We campaign to improve services, raise awareness and promote understanding.

Our network of around 125 local Minds provides guidance and care directly to those who need it most. Local Minds offer specialised services based on the needs of the communities they support, including a range of arts and creative therapies.

The coronavirus pandemic is as much a mental health emergency as it is a physical one. Those of us who were already struggling with our mental health have fared worst, but we also know that many people who were previously well will now develop mental health problems, as a direct consequence of the pandemic.

The *Hold Still* portraits illustrate the impact of the pandemic in all its complexity and show how creativity, art and human connection can help us find meaning in unprecedented challenges. Proceeds from the sale of this book will go towards our work here at Mind, and will help us to continue to provide support to those in need, including our Infoline, information and advice services, and our vital work in local communities.

If you're worried about how you're feeling, have questions about mental health, or want to learn more about how you can support us, visit Mind.org.uk.

Mind is a registered charity in England and Wales (no. 219830).

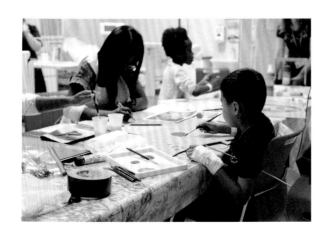

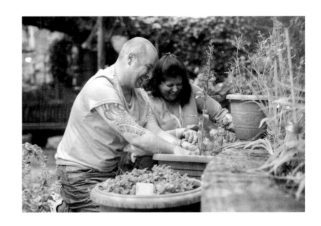

LIST OF EXHIBITORS

Lyndsey Adams
Kate Ainger and Coni
Hassan Akkad
Romina Amor Rabe
Julie Aoulad-Ali
Karni Arieli
Val Azisi
Angharad Bache
Jason Baird
Mrs Annette Baker
Diane Bartholomew Magalhaes
Alexandra Beeley
Lisa Bennett
Jill Bowler
Claudia Burton
Alun Callender
Johannah Churchill
Fabiana Connors
Phoebe Costard
Christopher Cox
Robert Coyle
H. De Klerk (aged 14 years)
Arnhel De Serra
Glenn Dene
Rebecca Douglas
Joyce Duah
Donna Duke Llande
Ceri A. Edwards
Trevor Edwards
Hayley Evans
Lesley Garven
Tricia Gilmore
Kenny Glover
Fiona Grant-Macdonald
Harry Hall
Roshni Haque
Ali Harris
Leigh Harris

Terry Harris
Kamrul Hasan
Ceri Hayles
Beth Hayward
The Revd. Tim Hayward
Anna Hewitt
Sue Hicks
Wendy Huson
Grey Hutton
Steph James
Simran Janjua
Steve Jenkins
Imogen Johnston
Joy (aged 15 years)
Georgia Koronka
Lisa Lawley
Sarah Lee
Sara Lincoln
Roni Liyanage
Melanie Lowis
Laura Macey
Niaz Maleknia
Marcela (aged 17 years)
Lisa Miller
Claudia Minchin
Fran Monks
Jocelyn Murgatroyd
Simon Murphy
N
Joe Newman
Jenni Norfolk
Jennifer O'Sullivan
Anastasia Orlando
Neil Palmer
Papajgun (Jamal Yussuff-Adelakun)
Rah Petherbridge
Tracey Philbey
Primrose (aged 12 years)

Helen Pugh
Rachel Louise Pugh
Anita Reilly
Kamal Riyani
Nina Robinson
Katy Rudd
Bonnie Sapsford
Kate Sargent
Rachel Scarfe
Alexander Scott
Chris Frazer Smith
Lynda Sneddon
Lotti Sofia
Jessica Sommerville
Victoria Stokes
Students from Maiden Erlegh
School (aged 13–15 years)
Amanda Summons
Kyle David Tallett FRPS
Karwai Tang
Kris Tanyag
Chris Taylor
David Tett
Julie Thiberg
Dr Ben Timmis
Rory Trappe
Matt Utton
Vedant (aged 12 years)
Nicole Paige Walters
Zak Waters
Sarah Weal
James Webb
Ania Wilk-Lawton
Daphney Wilson
Joe Wyer

LIST OF PICTURE CREDITS

INTRODUCTION
Photograph Credit: Matt Porteous/© The Duke and Duchess of Cambridge

CO-OP
© David Parry Photography

COMMUNITY EXHIBITION
Calton Road, Edinburgh, © Chris Watt/United National Photographers; Latchmere Road, London, © Ian Stratton/United National Photographers; The Hydro, Glasgow, © Andy Buchanan/United National Photographers; Battersea Park Station, London, © Ian Stratton/ United National Photographers; Bitterne Road, Southampton, © James Newell/United National Photographers; Waterloo, London, © David Parry Photography; Murrayfield Stadium, Edinburgh, © Chris Watt/United National Photographers; Swiss Cottage, London, © Teri Pengilley/United National Photographers; St Andrews Place, Cardiff, © Simon Ridgway/United National Photographers; Waterloo, London, © Tim Kavanagh/ United National Photographers; Heath Mill Lane, Birmingham, © Richard Grange/United National Photographers; Burleigh Street, Cambridge, © Tim George/United National Photographers; Wilmslow Road, Manchester, © Neil O'Connor/United National Photographers; St Leonards, Edinburgh, © Chris Watt/United National Photographers.

MELANIE MURAL
© Mural Republic
© Jon Super/United National Photographers

NATIONAL MEMORIAL ARBORETUM
National Memorial Arboretum, Alrewas, Staffordshire, © Express & Star

JUDGES
© Kensington Palace

NATIONAL PORTRAIT GALLERY
© Marysa Dowling
Creative Connections is generously supported by the Palley family.
The Hospital Programme is kindly funded by Delancey.

MIND
© Mind

Published in Great Britain by National Portrait
Gallery Publications

National Portrait Gallery
St Martin's Place
London WC2H 0HE

Published to accompany *Hold Still*, the National Portrait
Gallery's online digital exhibition from 14 September
2020 (ongoing), the nationwide community exhibition
from 20 October to 15 November 2020 and the National
Memorial Arboretum digital exhibition from 23 October
to 6 December 2020.

The captions accompanying the *Hold Still* images were
written between May and September 2020 and have not
been updated with subsequent events. The *Hold Still*
project and this accompanying publication reflect this
specific time during the UK lockdown. The text by Lemn
Sissay was written to mark the launch of the *Hold Still*
online exhibition.

The publication of *Hold Still* has been made possible
with the generous support of

With thanks to Co-op's team including Lindsey Laycock,
Parvati Elam, Aimi McNeill and Co-op's project partners
dentsu, ITG, Mural Republic, Posterscope and United
National Photographers who together helped bring *Hold
Still*'s outdoor exhibition to communities across the UK
in October 2020.

The digital exhibition was supported by international law
firm Taylor Wessing, long-time sponsor of the National
Portrait Gallery.

The net proceeds from the sale of the book will be
equally split to support the work of the National Portrait
Gallery and Mind, the mental health charity (registered
219830).

For a complete catalogue of current publications, please
visit our website at www.npg.org/publications

ISBN 978-1-85514-738-6

A catalogue record for this book is available from
the British Library

10 9 8 7 6 5 4 3

Director of Commercial: Anna Starling
Publishing Manager: Kara Green
Project Editor: Tijana Todorinovic
Design and Art Direction: Jeremy Coysten and
Jonathan Leonard at North
Layout and Artwork: Léa Aubertin

Front cover: *Melanie, March 2020* by Johannah Churchill

Back cover: *Biba Behind Glass* by Simon Murphy

Printed in the UK by Gomer Press

Origination by Dexter Premedia Ltd

This publication is printed on FSC certified paper and is
carbon balanced with the World Land Trust.